Press the Red Button

Thanks Lois

Julian

Press the Red Button

How to show up on video and win more trust, more authority, more clients

Julian Mather

Julian Mather

CONTENTS

CONTENTS

Julian Mather Publishing

julian@julianmather.com

www.presstheredbutton.video

Ordering Information:

Quantity sales. Special discounts are available on quantity purchases by corporations, associations, and others. For details, contact the author at the address above.

Press the Red Button/ Julian Mather. —1st ed. 2021

Are You a New Video Professional?

I can't get enough of it!
Rochelle!

Here's what she wrote in full: 'I had a real psychological block about recording myself on video. Julian showed me the importance of authentic videos and taking imperfect action. I just followed all his steps and now I can't get enough of it!' Rochelle[1] is a new video professional.

What's a New Video Professional?

New video professionals are busy business professionals who find video too technical; they don't feel comfortable in front of the camera, and they don't know what to say. Regardless, they decide it's important for their business that they turn up on video. So they learn new rules and they get new tools. Then, imperfectly and humbly, they show up on video. They do it consistently, so, over time, they become *the one* — the trusted authority that everyone wants to do business with.

Should I Care?

Four things have created a window of opportunity for new video professionals. There's a chance to leave your competition spluttering in your digital exhaust. You definitely should care.

1. We're Going Paperless

The digital transformation is on. Digital used to support the physical world, but the tables have turned. The world's biggest accommodation company, Airbnb, owns no hotels. The world's biggest movie house, Netflix, has no cinemas. The world's biggest taxi company, Uber, has no taxis. The world's biggest retailer, Amazon, initially got that big without any stores. Brick and mortar are becoming click and order. Some call it a digital shift. You can choose what you name it but you can't choose to avoid it.

2. We're Addicted to Convenience

Whether it's on the bus or wide awake with 3 am insomnia, we've become addicted to the convenience of smart devices. Problem is, text on smart devices is fiddly. Who likes typing with their thumbs? Not me. Video is more convenient. We're also addicted to the convenience of information at our fingertips. Digital video is the new window shopping, the new sales clerk, the new instruction manual.[2] We expect instant gratification, so don't ask us to book a call with your salesperson. Just show me already! Show me how to fill out that form. Show me how to fit the tap washer you just sold me. Show me your commitment to a diverse workplace. Show me how your app works. Don't make me jump through hoops or I'll walk. Customers say that satisfying immediacy is often more important than loyalty.[3] The digitally aware consumer is maturing and has reached a critical mass. They dictate the terms now.

3. We Trust People More Than Brands

There's been a profound shift in who we trust. Banks have let us down. Churches have let us down. Politicians have let us down. Trust in traditional organisations has been damaged. At the same time, our trust in each other is going up. We trust strangers to take us to the airport in an Uber more than we trust the CEOs we work for.[4] We search online

for unbiased consumer reviews from people just like us. Hyped-up corporate videos with hollow promises don't work like they used to. We're all tired of feeling manipulated and we're all pushing back. Customers are demanding authentic videos. We want real people giving straight answers. Human-driven, face driven videos are a must.[5]

4. Someone Threw Fuel on the Fire

It'd be nice to bring you the breaking story of video becoming an essential communication tool but apparently, some guy named Mark beat me to it. Did you read Mark Zuckerberg's writing on the wall back in 2016?[6] He said, "We see a world that is video first with video at the heart of all our apps and services." Then, just a handful of years later in March 2020, a virus threw fuel on the digital fire. Zoom took video communication mainstream. Video has landed in our lap and most of us aren't sure what to do with it.

Let me help you. Let me encourage you to capitalise on this video momentum like my video coaching clients - like Rochelle - and turn up on video, imperfectly, with vulnerability and humility, with a service mindset and become *the one* — the trusted authority in your niche who is building a steady stream of clients. I don't know how many years it will be until everyone is doing this, but by then, it'll be too late.

Right now, this is up for grabs. There are no gatekeepers. There's next to no cost. There's no reason it can't be you.

Could I Be a New Video Professional?

Bet you something. I bet you're already a new video professional and you don't even know it yet. Here's my thinking. I know you're not an amateur. The Latin word for "lover" is *amator*. It evolved to the French *amateur* to mean "those who love doing something."[7] Are you reading this for the love of video? Didn't think so. You are squarely a different-breed. You probably feel pressure to improve your digital skills or maybe

you have a commercial imperative to use video but, the truth is, you would rather not be here at all.

In my 40 years of making videos, I've found that most people don't give a toss about how a video is made; they just want to watch and enjoy it. They certainly don't want to be on it. Does that sound like you? You're not alone. For decades I've seen CEOs, politicians, sports stars, military officers, scientists, writers and even actors, all look and feel uncomfortable in front of the camera. They are masters of their domain one moment then sweating it the next because all of a sudden, there's a piece of glass — a lens — opposite them.

But you must be in front of the lens, on video, serving your clients. There is no way around it unless, of course, you want to become invisible to your clients. Didn't think so.

What's Stopping You?

It's not money. It's never been cheaper to make videos. I have gifted best-of-class training to many who have done nothing with it. The truth is we're scared. We're scared of damaging our image and our status by looking less than perfect. So we procrastinate and instead of taking action, we search online for a magic pill that will make us instant video sensations, and that's when it gets really confusing.

The Cult of the Amateur

First page Google results are home to the cult of the amateur. You'll be told that high production value is everything by an army of cinematic warriors armed with gizmos galore and a lot of enthusiasm. I admire their skill. But new video professionals should question their advice. Has it been tested in the pressure cooker that you need for the daily grind of typical business videos?

You'll be told AI-powered apps can magically make attention-grabbing videos for you. There's some truth that you need to grab attention.

It's also fundamentally flawed. More and more people vying for attention don't get more attention; they get less. The maths doesn't add up. These are video bubblegum machines. It's video spam, really, which is perfect if you treat your customers like one of the herd. It is a waste of time if building relationships matter to you. Relationships matter to me. So rather than guess what new video professionals want, I asked. I started mentoring and coaching clients one to one to get a deeper understanding that I couldn't get from on-site workshops and speaking from the stage. This book is my answer to what is stopping you.

Can You Trust Me to Deliver?

I've seen the world through many lenses. Through the scratched lens of a hand-me-down camera as an amateur photographer since age eleven. Through the narrow lens of the rifle scope; that was my view of the world for three years as an army sniper. Through the wide-angle lens of a globe-trotting TV cameraman where I honed my craft to the world's standards and shot for big networks like ABCTV, BBC and National Geographic. Through the eyes of a professional magician doing 2000 magic shows. Watching the faces of the audience staring back at me taught me first-hand about audience psychology. Through the slog of feeding a YouTube channel to get 30 million views and 140,000 subscribers. Through the discipline of the thousands of videos I presented from a small home studio to keep my business going. Through the privilege of speaking to thousands from the stage as a professional speaker. Through running video workshops for small businesses to corporates to government departments; every session gave me another opportunity to simplify video further to make it more accessible. It's been a long journey to arrive at the word *accessible*. Video has to be accessible. Millions upon millions, yourself included, need it to be. Sadly, it's not.

My superpower is understanding the 'video experience'. I know how humans react to and interact with video. I know what you're up against when facing video for the first time professionally. I know what it feels

like to be in front of the camera for the first time. I know I can make it easier for you.

Here's My Promise to You

Sammy the Bull Gravano stopped me in my tracks. Literally. This mafia underboss said something on a podcast.[8] It was the most compelling customer satisfaction guarantee I have ever heard. Around twenty years old, he was invited into a mafia family by the boss.

The boss said, "Listen, Sammy, you got to hook up. You're a tough kid. You're in fights. You know what's going to happen. Someday, you're going to hit the wrong guy. They're going to find you in a trunk. You come with me. You'll be part of a family." He said "I'll never lie to you. I'll never backstab; whatever I ask you to do, I've done. And I will do it with you."

"I'll never lie to you. Whatever I ask you to do, I've done. And I will do it with you." I have adopted this. What this book asks you to do, I have done. You can be sure when you are doing it, know that I am there doing it with you.

If you take action with what I have laid out in this book, then, instead of lying awake at night having thoughts like, I suck at making video, I'll look amateur, and I'll forget what to say, you'll go from cursing video to crushing it with video. You'll feel an overall rise in your confidence. You'll start to feel comfortable in front of the lens, and others will envy your newfound skill. You won't just be fast at creating videos; you'll be prolific. Your trust and visibility in your marketplace will improve. Word of mouth will start replacing ad spend. You'll be on your way to a steady stream of clients. You'll be the one everyone wants to do business with.

What This Book Covers

All my life I have been frustrated by poor teaching, and in all fairness, at times I have been an equally poor student. I need to know the WHY. Why I am doing it? For what purpose? Without the WHY, I lose interest fast. So, expect the WHY of the technology as much as the HOW. That's because the WHY will let you make decisions independent of outside help. You'll implement faster. You'll be cost-effective and reach more new clients.

Over time, you'll also need to work on video strategy, video presentation and video skills. This book, to be clear, is squarely focused on video skills, in particular, unlocking the video power of the world's most effective yet inexpensive sales, marketing and communication tool: the smartphone you already own. What you learn here will work with a webcam, DSLR or RED camera. That's because regardless of your tech, good habits earn you money.

If you want to change how you or your organisation thinks and feels about video, and if you want to unleash your inner video star and strive to be utterly compelling on video, then come to one of my *Fearless and Famous* keynotes and masterclasses. Rest assured that there are plenty of times I will dip in and out of many presentation skills on these pages.

If you want a strategy for you to be seen as a trusted authority, then attend my *Be The ONE* masterclass. But right now we have to attend to one key piece of the video strategy puzzle: the video production paradox. It starts with clients having a big appetite for video, but not just any video — authentic video.

What Is Authentic Video?

Authentic video is the opposite of highly polished, precisely scripted, perfectly presented corporate videos that leave you feeling manipulated. Authentic videos typically feel less scripted. Authentic videos are not about quality. They can look amateurish or be beautifully packaged. The authenticity is in the person and the message. Would the person on the screen be the same if you met them on the street? Would they tell you the same thing if you met them over coffee? Authenticity is directly related to how trustworthy the video feels.

The Video Production Paradox

If trust matters to you and your business, then the video production paradox matters to you. Every business will need a mix of both traditional, professionally made videos and authentic videos typically made in a DIY style. Things have changed. Five years ago, all a business needed was a website video and a few product videos. The customer demand for video, most of it authentic, is now driving the need to create videos. In short, we need to be making a truckload of videos these days: FAQs, social, updates, explainers, training, testimonials. How are you going to meet this growing demand for authentic video? Enter the video production paradox.

You Might, They Can't

You might be able to make highly polished professional videos. I don't know your skillset. All power to you if you can. But professional video production houses can't make authentic videos. It's not in their language. It's not in their DNA to make videos that don't look professional. They try. Maybe 1% pull it off. Generally, the harder they try, the worse it gets.

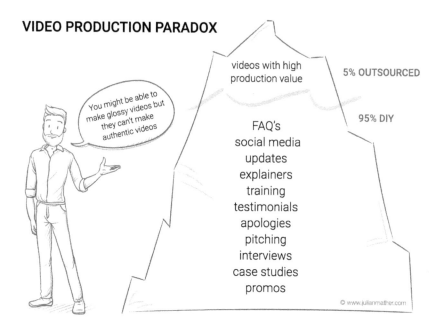

Witness those bank and insurance ads that mimic a homemade look and feel to back up a script that purports that they have been with us through the important moments of our lives, like the birth of our children, the first day of school, the first kiss... you know the type. Argh... don't pretend you know me that well (though they probably do with the amount of data they have on me!) and that we're friends. It's often insincere and leaves a bad taste.

So the paradox is you might be able to make the videos they can, but they can't make the videos you can—the kind of genuine authentic videos that customers are asking for. That's because you can't be a little bit authentic. It's either authentic or it's not. You might, they can't. So if they can't, who has to?

PAUSE FOR EFFECT

That's right—you.

What You Need

New video professionals need a strong spine, an open mind and a good pair of shoes. A strong spine to not be distracted by shiny objects. An open mind to stay up with technology as it twists and turns. A good pair of shoes because it is a long journey to winning customer trust.

You also need a smartphone and a smile.

Operating Instructions for This Book

Turn on the utility
Write in the margins. Dog-ear the pages. Capture your ideas.

Watch the videos
Follow the links and QR codes

Get The Tools
Follow the QR codes

Nothing makes sense
The mind is like a parachute: it only works when it's open.

Nothing's working
Try again. It works wonders.

Still not working?
Get a refund. Seriously. That's ok.

2

Your Video Journey

What path will you take?

I was lucky. I had an amazing three-year traineeship with ABC TV in Australia. I was exposed to film and video, editing, sound recording, radio production, working with symphony orchestras, news and current affairs, outside broadcast and studio production.

On my first day of studio production, an educational drama was in progress. I was young and fit and strong, so I was put to work helping move stage sets in and out. The first piece of stage furniture I was asked to move was a beautiful wooden bookcase. It was full of hefty law books. *Arghh! This is going to be heavy. One. Two. Three. Lift.* I almost launched this bookcase into the lighting gantry above. It was made of Styrofoam.

That was my first insight into the economies of TV production. Styrofoam sets are fast to bump in and bump out. Television is expensive. Lots of people, lots of equipment, lots of egos. These all cost money. Other people's money. There was a commercial imperative to save time. Disciplines and techniques that saved you time meant you saved money. Every business has the same commercial imperative to work faster and more efficiently. The disciplines from TV will sit well with your business video needs. The job descriptions will too.

Presenter, Interviewer, Reporter, Storyteller

Presenter - Getting face to face with your client will make up 95% of all your videos—video messages, explainer videos, welcome videos that rehumanise your business. Some presenters only present. Their skill is to turn up in front of the lens with a script and deliver a message while making you feel comfortable. Think Sir David Attenborough.

Interviewer - Establish yourself as an authority in your field by getting others to do the talking. The new tools make this so easy. This is a great way to create content for social posts. Interviewers can start great conversations yet at some stage, they present to the camera, so interviewers need presenting skills also. Think Oprah.

Reporter - Show us what's happening. The new product ranges arrive. The community day is set to go. *Let me introduce the new team to you.* Reporters need to present, interview and gather the relevant B roll to illustrate the story. Think nightly news.

Storyteller - Stories are serious business. Tease out simple stories from your people and your business journey and end them with a lesson that adds value. Weave narratives throughout a video series, longer promotional videos and training courses. Storytellers need to present, interview, gather B roll and weave a longer storyline. Think Louie Theroux.

Editor - Becoming a good editor takes time. Most new video professionals are busy people. I recommend you don't do much editing. Rather, outsource your editing. We'll talk about this in detail in the last section of this book. I wanted to mention it here as the thought of editing scares off a lot of people from starting their video journey. It's changing fast. There's no need to fear editing any longer.

What do you think you might need as the presenter, interviewer, reporter, and storyteller? Whatever you choose, you will need all the skills to the left of your choice and none to the right. If you choose presen-

ter, you'll be getting out of class early. Storytellers, you'll be reading right through to THE END. You can add these to your CV: Presenter | Interviewer | Reporter | Storyteller.

Your video journey must start with you fronting up on camera. You are the one who will build trust, not an animated explainer video. Not a bouncy bubbly video meme. You. Imperfect ol' you. Video for business starts with you presenting. Presenting is key to your success using video as a business tool. Presenting is where the new video professional's journey must start. There is one more role I want you to consider on your video journey.

Video Buddy - TV and print newsrooms have sub-editors. They are the grammatical gatekeepers, and they impartially look at journalists' scripts and stories without emotion. Their job is to ensure good story content and good writing, but most of all it is to keep you and your emotions out of your video. Your struggles as a video maker mean nothing to your audience. No one cares that it took weeks to get that one shot. No one cares about the labour; they just want to see the baby. We all need a bit of *subbing*.

One of the reasons I created the New Video Professionals Club is so you can get a video buddy. They cast an objective eye over your work. You do the same for them.

Join the New Video Professionals Club

Now, how much do you need to know? Ah, this one is easy.

How Much Do I Need to Know?

You're likely familiar with the Pareto principle, AKA the 80/20 rule: eighty per cent of the results come from twenty per cent of the effort. This uncanny rule that shows up throughout nature, throughout the physical world and throughout our daily routines also showed up in my

TV career. There was an essential twenty per cent of what I shot, over and over and over. E20 is my shorthand for the essential twenty per cent. This is all I teach to busy new video professionals: E20 Pre Production | E20 Production | E20 Post Production. It's all been pressure tested for decades in the non-stop video factory of television. Use this, and not only will have an advantage over others lost in the weeds of online cinematic how-to videos, but you will feel a conviction in your methods and you will feel secure to share them with confidence. You can fill in all the details for your particular situation by searching Google.

E20 VIDEO PRODUCTION

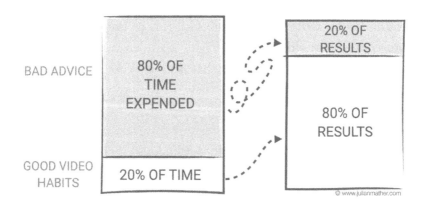

You're close to starting the E20 Pre Production | E20 Production | E20 Post Production process of making videos but first, I'm going to let you in on a secret.

Real Secrets

First Principles for New Video Professionals

The tech will come and go, but these principles will stand strong. I live by these. Why? Because they work, and I'm only interested in what works. Write these on a card and keep them visible. They set new video professionals like you apart from the herd.

The Most Expensive Information in the World is Bad Information - I have looked at dozens, maybe a hundred cardboard boxes brimming with unused video gizmos. *Somebody said we should get this but we didn't know what to do with it.* Stop buying problems.

Tools, Not Toys - Did you know that professional cameras have hardly any of the extra features you find on consumer cameras? Nine out of ten features are gimmicks. From this point on, we're finished playing with toys.

Little Hinges Swing Big Doors - Simplicity = reliability = a greater chance of success. I was taught this as an army sniper. I owe many successes to not overcomplicating things.

Start with What You Have - You don't have to pay big to play big on the small screen. You already have Hollywood in your handbag. You already have a pocket-sized TV station, an anti-invisibility device

for your business and the Swiss army knife of business tools at your fingertips. You already have a smartphone video advantage. Use it.

Be Fast - We all must make videos in minutes, not months. Everything you consider must reduce friction, not add to it. If video is a hassle, you simply won't do it.

Good Video Habits Earn Money - It's your money. Nurture habits that allow you to be on budget, on time, every time.

Distractions Dilute Your Message - distracted viewers aren't listening and taking the action you want. Stylistic video gymnastics and contortions can be fun but commercially make no sense. Use with care.

Shortcuts in the Field Often Cost Double in the Edit - Saving time and money is always appealing. Fixing recording mistakes in the editing room almost ALWAYS costs more than the money saved upfront by rushing, cutting corners, slipping into bad habits.

You Won't Win a New Game Playing by Old Rules - Digital communication is evolving fast. Really fast. Stay ahead at the New Video Professionals Club.

Remove Barriers - Ever driven along and the car feels underpowered, then duh! You realise the parking brake is on. If you aren't making progress, first consider that an existing belief might be the problem. There's nowhere you'll need to understand this more than when you start video presenting. I started video presenting at the same place you will: never having done it before. What I would have loved is someone, like I'm doing now, to shine a light on the ill-founded fears and assumptions I had made about presenting that were simply wrong. Let's start.

Unleash Your Inner Video Star

*How do you know if you have never
tried?*

Many of my clients have strong opinions that they suck at presenting videos before they've ever made one. Once they begin their new video professional journey, they soon realise that great presenters are not born, they are made. I've witnessed humble humans go from shy to shine many times. Myself, I personally have gone from being a stutterer to being pretty good at presenting. If I can do it, you can do it... and you *can* do it.

If you want to get serious about your video presentation, come and join me at one of my Fearless and Famous sessions. It's the fast track to get on the path to being utterly compelling on video. But why wait? Let's start. Right now. You can change how you think and feel about video presenting with these two words...

Be You

It seems odd that, as mature adults, I need to try and help you be yourself. Just being you should be so easy, yet we live in a world of comparison that makes it so hard. Start to put all the stories you have concocted about yourself to one side and replace them with this simple truth: your clients want a person, not a persona.

How to Be You

This is my daily formula: STAND FIRM| BE CLEAR | STAY TRUE. It works well for me. Try it for yourself.

Stand Firm

Who Said You Can't Be a Video Star? - You don't need to ask anyone's permission to want to show up and help your clients. There are no gatekeepers.

If Not You, Then Who? - I say there are people waiting for you to show up on video. Why are you keeping them waiting? Tell me, who knows your clients and problems better than you? Is there someone better? Didn't think so. It's you. Don't deny those who most need your help.

Build Trust - Trust is your most valuable online currency. We share what we trust. It's no longer about who you say you are; it's about who Google says you are. If you break trust, it's on the record. If you want to be trusted, it's **show**-time!

Show Respect - Solve, don't sell. Being sold to sucks and being manipulated hurts. Trusted authorities make people's life's better, not worse. Show respect by not wasting your client's time. Instead, invest your time in making videos that benefit your clients. Julie Masters advocates the *keep it or share it* rule. Would they want to keep it? Would they want to share it?

Show Don't Tell - Video is proof that your ideas/your convictions/your actions have integrity. People want to see you walk the walk, not just talk the talk. Stop hiding behind your words.

Show Up Daily - People want to see before they buy. Show up on social. Show up on your website explainers. Keep showing up as their trusted advisor and when the time is right, they'll find you.

Take a Daily Dose - I say that turning up on video is not hard, but I guess it all depends on your idea of hard. This is mine: losing somebody in my life I love. Turning up on video is not hard. It requires only a daily dose of mild discomfort. A few butterflies in the tummy. A little bit of stick-to-your-guns-and-do-it.

So stand firm in the knowledge that you are qualified to speak, you are entitled to show up and there are people waiting for you to show up and improve their lives.

Be Clear

Confused people don't buy.

Get Clarity - People buy certainty. Can you explain your product or service with conviction? Can you sum up your video in one sentence? Clarity of message is like a shot in the arm to your confidence.

The Wrong Customer? - Who are you making the video for? Are you clear on this? Really? I don't even know you and I bet you I can answer this, with certainty, on your behalf. *Not you.* We make our videos for clients and customers, yet we unwittingly fall into the trap of making them for ourselves. *I prefer these titles. This music makes me feel good. It needs to be of a certain standard before I publish.* Says who? Certainly not your audience because you've probably never asked them. Nor do they care about your aesthetic tastes. You are not your customer.

Get Scripting - Scripting matters. Scripting gives you so much control. Scripting makes YOU think so your audience doesn't have to do

the hard work. If nothing else, knowing your first and last words will boost your confidence.

Get Visual - You can't expect a screen share video with PowerPoint to compete with YouTube, TikTok and Netflix. When you are on the small screen these platforms are your competition. We must video-fy our messages if we are to compete. It doesn't require you to be Steven Spielberg, but it does require you to put some thought into it.

Stay True

The great thing about BE YOU is you don't have to change who you are. You do however need to understand what's going on in your body, in your head and in your heart.

Just Be You - Gary Vaynerchuk says the world is stuck in high school.[1] I agree. We think there is something wrong with us and spend our time trying to fit in. People want you with all your lumps and bumps and your wrinkles of a life well-lived. Video is not the secret sauce— you are.

Know Your Body - Video phobia, camera shyness and camera anxiety are all rooted in fear. Fear causes your body to react. The physical changes you are feeling are meant to happen. You are designed that way. Our job is to manage these feelings. Out of every session that I run, this is my favourite. It liberates people. Right now just know—and I say this hand on my heart—there is nothing wrong with you.

Our Problem with Perfectionism - Most of us are products of a binary education system. There's a right answer and a wrong answer and you are reprocessed through the system until you get the right answers. We've been trained to idolize perfection. Our first experience speaking in front of an audience was at school. We were graded on oral exams. We

were marked. We are imprinted with a belief that there was a right way and a wrong way to present. Not so good for authentic videos. Make mistakes. Rinse and repeat. Adjust. Rinse and repeat. Learn fast. Rinse and repeat. Improve.

Will I Forget What to Say? - Only if you try to remember. We can design simple scripts that turn a memory feat into an easy conversation.

Will I Look Amateur? - Only if you try to look professional. So don't try. You might inadvertently look and sound like a politician. Yes, the wrapper matters. Put thought into how you appear but put more effort into your willingness to be vulnerable and imperfect.

Fix Nervous with Service[2] - When all your thoughts centre on you and your appearance and what others might be thinking, there is no capacity for you to truly turn up in the spirit of service. A man wrapped in himself makes a very small package indeed. So approach your videos with a service mindset. Clients LOVE it. Service is the new video sexy!

Dealing with Your Video Critics - Are you worried people might criticise your video efforts? Newsflash: none of us is as important as we think. People haven't got time to remember our small mistakes. There is way less criticism than we imagine. In fact, I have found it to be the opposite. If you show vulnerability and say, "This video thing is new for me and I'm just finding my feet," then you'll be surprised with the support and encouragement from the sidelines.

So STAND FIRM | BE CLEAR | STAY TRUE.

I'm there right beside you, feeling the same feelings. Nothing bad has happened to me; the opposite actually. I want you to feel safe trying. Do you feel safe?

E20 PRE PRODUCTION

The best magician in the world can't produce a rabbit out of a hat unless there's already a rabbit in the hat

The ABC of Video

Make video pop songs

Pull your smartphone from your pocket. Tap the camera mode. Select selfie. Preen yourself. Press the red button. Record yourself speaking your truth. If you are utterly compelling in your message and ooze charisma then this, the simplest of all business videos, may well be the only style of video you ever need to make.

Most of us like to think we have utterly compelling messages and we dream of oozing charisma, but we haven't and don't. We could use a little help. The good news: the language of filmmaking works brilliantly to amplify your message. It's free and you don't need much.

Drama| LIVE | Factual

We're not talking about making Hollywood features. That's dramatic film-making. Neither are we talking about LIVE television, like sports broadcasts or *Big Brother*. Welcome to factual. This is the world of information-driven content like news and current affairs, magazine and documentaries. If it were music rather than video, we would be writing pop songs instead of hour-long symphonic pieces for orchestras.

Sure, it's not easy to write a hit song, but pop songs have a tried and tested formula. *Intro, verse, chorus, verse, chorus, finale,* and they're about three minutes long. What if we had a formula like this to make short 3-minute business videos? We do. It is remarkably like a pop song. I call it the ABC of video. It consists of three elements: A roll B roll C

roll. The simplest, fastest and often most powerful business video is the A roll, so let's start there.

A Roll

Skip back to the first paragraph of this chapter where you are speaking directly to the camera and sharing your message. That's the A roll. Equally, it could be you interviewing someone or you being interviewed. Typically, someone visibly speaking on camera, delivering a message | telling a story and driving the narrative forward is considered A Roll. This is known as a *talking head*. When you're recording the bits and pieces of your video, if you are ever confused as to what is A roll or b Roll, there's a simple test. If you close your eyes and can still understand the message/story just by what you hear, then that's A roll.

The problem is A roll is b-o-r-i-n-g. Too many *talking heads* in a video loses viewers. When we are on the small screen, our competitors are the likes of YouTube, TikTok and Netflix. Video is a visual medium. The A roll alone may as well be radio or a podcast. So to make our videos interesting, we add B roll.

B Roll

The B roll is video vision that illustrates what is being spoken about in the A roll. If you wanted to share your opinion about new rules governing walking dogs in city parks, then your video would need A roll, including you speaking into the lens, possibly interviews with a local council official and a dog owner. Your B roll would relate to the information in the A roll and likely include vision of people walking dogs, dogs playing, city parks, park signs and local government offices.

Now you stitch A roll and B roll together in the editing process to make your video story.

The Edit

Much like the pop song consists of *intro, verse, chorus, verse, chorus, finale,* a typical business video goes *intro, titles, A roll, B roll, A Roll, B roll, ending with a call to action.* On one hand, this is an overly simplified explanation; on the other, there's really not much more to it.

In the edit, you start by joining all the best bits of the A roll together in a way that tells the story. Remember, at this point, if you closed your eyes, you could still understand the story. Then you replace most, not all, of the boring A Roll *talking head* pictures with more interesting B roll images. We don't actually remove any A roll; we simply replace the A roll pictures with more engaging ones. Watch any news story and you'll see pictures showing you what happened while the reporter's voice is telling you what happened. I like to say that the A roll is for the ears, the B roll is for the eyes. What about the C roll?

C Roll

The C roll is all the other bits or collaterals that you see and hear in your videos—music, logos, titles, lower thirds. Typically these stay constant from one video to the next and enhance your branding. It saves time if you make up editing templates incorporating these elements that you import fresh A roll and B roll into. *Note: C roll is a name I made up from collat-e-ROLL. You won't find this in online searches, that is until new video professionals like you make it commonplace.*

Follow this link or scan to QR code to go to all the accompanying videos, resources and recommendations mentioned in this book.

Get your extras by
scanning this QR
code

X-Ray Video Vision

Once you grasp this basic architecture of a factual video, you will forever see all videos with a fresh perspective. Most videos are made on a variation of this simple pop song frame. You now have X-ray video vision. You can see inside videos. You can take inspiration from others. You can copy what others are doing. Don't worry, everything's already been done before. Just put your own spin on it. You will never run out of ideas again.

Getting an appetite for video? It's time for a sandwich...

* * *

" "Julian made the scary possible and now making my own videos is as natural as breathing" "

Jacinta Cubis, Facilitator, Melbourne

" "You helped improve competence and confidence in our senior leaders" "

Stuart Jenner, Gold Road Resources

" "The team is absolutely buzzing. Gone are the fears of appearing on camera" "

Caet Young, Head of Comms at GIVIT.org

Scripting

Good video habits earn money

Finally. Let's make a video.

The Video Sandwich

If a video was a sandwich, then video pre-production and video post-production would be the slices of bread and video production would be the filling. The filling is like your story. It can be any flavour, size, and combination, but those slices of bread on either side are constant. Without those two pieces, it's not a sandwich. My shorthand for pre-production is scripting, and post-production is editing. Scripting influences editing. I've worked with scripted and unscripted directors. I've made my own scripted and unscripted videos. I will never go unscripted again.

Scripting

Opening your mouth and just letting the words tumble out is not commercially smart. Making videos means you need to write. Not well, not for anyone to see, not for anyone to judge you buy. Just to make you stop and THINK about what you want to say before you say it. It is not your viewer's job to think for you. Trusted authorities don't make their clients do work that they were too lazy to do. Clarity is a by-product of scripting. Viewers love clarity.

A video script is also a safety net. It lets you create videos like a tightrope walker. You can be a little daring. You can take chances. You can wow the audience. But if you stumble and fall, just like the walker faces no consequences, you simply return to your script and continue on schedule.

A video script is a blueprint. If you can't or don't want to complete your video, you have the architect's plans to hand over to someone. Taking the time to write a script will save you time and money.

Kill the Comma

Writing out a video script requires that you unlearn everything you learned in grammar class. Specifically, the use of the comma. As wonderful as commas are, they have no place in your video script. Right now look at pages of this book before and after this section. What you've been reading to this point is me writing for the page. The following piece is exactly what one of my video scripts looks like...

If you speak conversationally
then write conversationally
that's in short bursts
without commas
without full stops
without a thought in the world for correct grammar
and... sometimes....
if you decide to ramble on and on and on and on
that's ok ... because...
you know there's a word coming up
*that you can put an **EMPHASIS** on*
that will get your audience's attention back

To be clear, the lines that you see above is how I actually write scripts. A few words to a line. Once your script is in a first draft, highlight all the

text and do a word count.[3] How does your timing stack up? Most first-time video scriptwriters are shocked at how few words it takes to speak a minute. The guide below is reliable. You don't have to be accurate, just in the ballpark. Why? Because shortening your script now, before production starts, is much less expensive than finding out during the edit that you have to do a reshoot.

30 seconds = 70 words
1 minute = 130 words
2 minutes = 260 words
3 minutes = 390words
4 minutes = 520words
5 minutes = 650words

Writing a video script for someone else to read is problematic. We all speak idiosyncratically. Scripts need to be in 'our voice'. If you pen words professionally for others, then the responsibility rests with you to put your ego aside and let the speaker of the words rewrite your work to suit them.

I get that not everyone is a writer. Please don't feel intimidated. If you can jot down some points, you can do this. Remember, the point is to be clear in your message so your viewer doesn't have to work out what you are trying to say. That's all. If you are worried, you should use script templates.

E20 Script Template

I use templates all the time. It's scripting without pain. This isn't a book about scriptwriting. If you would like to work with me to create your own templates, you can. Just ask. What I can give you is my E20 video template. So many of my videos adhere to this simple framework:

TEASE | TITLE | TRANSFORMATION | TEACH | TAKEAWAY | TASK | TITLE

TEASE - Ask a question/state a fact /challenge an assumption. Start with an interesting hook.
We live in a world where...
Did you realise that ...
When was the last time you...

TITLE - Never put your video title at the start. No one has time to watch titles now. Put it here and make it short. I recommend no more than 3 secs OR you can simply introduce yourself at this point. *Hi I'm Julian Mather...*

TRANSFORMATION - The viewer will already be asking 'What's in it for me?' This is where you promise to transform them if they keep watching. Promise to take them from A to B, from stuck to unstuck, from frustrated to liberated.
What if...
Would it be good if...
Imagine...

TEACH - This is where you deliver on your promise above. This is the body of your video. Maybe tell an engaging story. Maybe explain the 3 steps to take. Maybe share what's been on your mind. Just make it pithy and to the point.

Stuck writing the body of your script? This simple hack works well. What questions would your student/client/viewer be asking right now at this point in their journey? Raise the question yourself and answer it for them.
The first thing everyone wants to know at this point is...

Stuck telling a story? Don't overthink it. Beginning, middle and end work well.

At first .. [problem]
Then we tried .. [action]
And now we ... [result]

Alternatives for the [action] above.
We realised we had a big problem when ...
We made a breakthrough when...
Everything changed when...

TAKEAWAY - We all love lessons. Share the takeaway lesson from your story

That's when I realised ...
I'd always thought ...
So I guess my point is ...
What this taught me is ...

TASK - What do you want them to do now? Put your CTA or call to action here.

I invite you to...
Right now go to...
Start now by...

TITLE - You can have an end video title to complete your packaging. Make it short. Mine is one second.

How Long Should My Video Be?

Time can do strange things to people. Lara worked in TV studios her entire career as a production assistant (PA). She was a very good PA. When I met her, she had a clipboard and stopwatch in hand. Those were

the tools of her trade: something to count the seconds with and something to note down those seconds.

You might think a half-hour TV program is thirty minutes long. It's not. TV runs to the second. It could be 28 minutes and 12 seconds or 26 minutes and 39 seconds PRECISELY. So Lara was struggling because she was on her first documentary shoot outside of a studio environment, and it was freaking her out.

We were in Australia's Northern Territory, 'the NT' as it's called, a place where the units of measure for spiders is 'dinner plate', for hail it is 'golf ball', and for time, there doesn't seem to be a unit of measure. It's a pretty laid back sort of a place. People operate by 'NT time'. Not today, not tomorrow, not Tuesday, not Thursday... it'll happen when the time is right.

Poor Lara's world fell apart. She had planned to use these six weeks of being away from the pressures of TV studios to get healthy again, to shed a few kilograms and to quit smoking. Lara was puffing away madly and stuffing down chocolates by the second week. How would she cope online now? She would be in the corner rocking if she had to operate in the online world today. There is next to no time discipline at all. There exists an attitude that the internet is endless, boundless. Maybe it is. Somewhere on the seconds to infinity continuum lies the answer to everyone's question, 'How long should my video be?'

The Long and Short of Video Length

TikTok extended its 1-minute limit to 3-minutes.[1] Hmmm. Is that a clue? In his book *The 3 Minute Rule*, author Brandt Pindivic says, "In every TV show, the conflict in each scene is edited to resolve at almost exactly the three-minute mark. *Shark Tank* uses this decision marker in almost every episode. From the time they introduce an entrepreneur to the time one of the sharks says, "I'm out", it is almost always three minutes"[2] Could 3 minutes be the magic number?

Hang on a tick. People will watch impactful and story-driven long-form videos regardless of length.[3] And that can benefit us. In business-related videos, engagement is highest for the first few minutes of video (typically above 50% for the first three minutes) and drops steadily after that mark. So, viewers who continue to watch are typically more engaged and are strong candidates for additional content from you.[4] Is long-form content smarter?

I think there is too much attention on us having shorter attention spans. I don't know about you, but I can binge-watch an entire season on Netflix. There's nothing wrong with my attention. The problem I see is we have too much choice. This leads to decision fatigue. So don't make your viewers work to get the value from your videos. This comes back to the importance of scripting.

Skip Intro

Do you hit the Skip Intro button when binge-watching Netflix? Audiences love it. You can trim ten to fifteen seconds off your videos by getting rid of those meaningless, glossy titles you were promised would set you apart. Sorry to shatter the illusion, but those titles have made you like everyone else who bought into the lie. Do you know who benefits from long titles? The people who make your titles. You fund their creative urges. I'm not criticising them for doing that. I just want you to know that we've moved on from videos with long titles. If you want a title, aim for three seconds. Better still, just have an animated logo in the corner of the screen that remains as a static image after the first few seconds of animation.

The One Word That Always Gets Attention in a Noisy World

My name. Make me an authentic personalised video where you speak my name and sincerely help me without manipulating me, and

you've got my attention. This is why personalised video messages are so powerful. Try it.

Be Brief, Be Sincere, Be Seated

So how long should a video be? Let me defer to the thirty-second President of the United States, Franklin D. Roosevelt. Nearly one hundred years ago he answered this question perfectly with Be brief, be sincere, be seated. Say what you have to say, say it with sincerity and then get off the stage. Every person making a video should have this tattooed on their index finger, so that every time they extend it to push the record button, they are reminded to be respectful of others' time. But you want that magic number, don't you?

The Magic Number

What follows is art, not science. It is feelings, not facts. It does however come from publishing thousands of business-related videos as a small business operator.

If my life depended on it, the number I would say is 90 seconds. That's my starting point. That's about 200 words on paper. I write - in short sentences - what I'm thinking and then apply word count. If I've written 600 words, then I immediately think, *Maybe this will end up as three videos.* I use this for social posts and updates and website FAQs. If you allow me wiggle room I'd say 60 to 90 seconds. That is to say, I aim for shorter where I can. However, I still find it hard to say what I want to say in under 60 seconds, but we have to remain disciplined. Here's why...

You Don't Buy Knowledge by the Kilogram

An easy trap to fall into, especially when making video training courses, is that more is better; more content equals more value you are

providing. I have been guilty of this so many times. We've moved on from the information age and into the transformation age. People are stuck and they want you to help them get unstuck as fast as possible. The truth is that people don't need your content. They can just Google it. People want the shortest way from A to B. They want you and your secret sauce that gets them there.

> A ship breaks down in the harbour. A mechanic is called. An old man with a small toolbag arrives. He runs his hands along the big pipes. His finger stops on one spot. He reaches into his bag and pulls out the tiniest hammer and taps the spot. BR-MMM! The ship fires to life. A week later the invoice arrives. $10,000. What! You were hardly there at all. Please send an itemized bill. It arrives. Tapping with the hammer $2. Knowing where to tap $9,998.

People want to know where to tap. Less is more. Don't cram. Put extra content in a handout PDF or link to more content. Keep your video courses tight. I aim for 3 to 5-minutes when making explainer and training videos.

Done. A compact chapter on compact scripts. Now, it's time to stop monkeying around with tech.

* * *

" Your scripts are awesome. Geez, I just took a copy seminar that Seth Godin endorsed. It was good, but yours is right on the mark.

Jerry Matecun, Financial Advisor, Arizona

The Smartphone Advantage

Unlock the anti-invisibility power of the world's most effective yet inexpensive sales and marketing tool: the smartphone you already own.

Kids and family magic is the bread and butter work for a lot of magicians. Fart jokes paid my bills for a few years. When I started children's entertaining, I was very nervous and received a lot of advice on reducing stage fright. Some of it wasn't so good. *Just imagine your audience naked* is terrible advice to give a children's entertainer.

I was also advised to put a puppet into my show. I drew the line at that. *This bloke does not stick a puppet on his hand! I am more sophisticated than that. I am cleverer than that.* Well, two years later, I had a puppet on my hand. His name was Peeky the Cheeky Monkey, and I wish I had started using him two years earlier. He quickly became the star of the show. Not just with kids, but with adults too. Groups of dads with beers in hand would stop their cricket discussion and tune in for five minutes. Huh?

There was something I didn't understand about puppets. It was something that Jim Henson who created the Muppets understood. When you use a puppet, you are animating an inanimate object. Bringing an inanimate object to life is a metaphor, a proxy, for bringing the dead back to life.

In our DNA, in our psychology, in the depths of our souls, if we lose someone we love, if we had one wish, we would use it to bring our loved ones back to life. This is why a silly $25 puppet was the star of my shows. There truly was magic in the air. At my expense, I dismissed using a puppet because I mistakenly thought it lacked sophistication. My ego got in the way.

I regularly see people's egos stopping them from using their smartphones to shoot videos. They tell me smartphone cameras are not good enough, that they need 'professional' video equipment. I don't think like them. If I could choose only one camera to further my business, with no qualifications and no exemptions, it is a smartphone. Here's why...

Speed Matters

Missing somebody? Call. Have a question? Ask. Want to be understood? Explain. Want to shoot business videos? Press the red button. Smartphones are fast.

Maybe you have just finished a community engagement event and someone comes up to you and is full of energy in effusive praise for your business. You don't say to them, 'I have to go to my car to get my camera; can you hold that energy for five minutes?' Maybe you are sitting next to a peer at an event and they drop a wisdom bomb. You wish your staff could hear what you just did. Now they can. Maybe you can shoot an impromptu training video of a new process as it is being explained to you, and have it in your team's hands before the end of the day.

If you can make videos with just your phone, you have an edge over those who can't. Imagine if your team could all make smartphone videos? You would have such a competitive advantage.

The Future Is This Way. Coming?

Photography is at a crossroads. One path is optical. We've made lenses about as clear as we can. We've made sensors about as sensitive as we can. We've just about reached the limit of how we capture images.

The other path is computational.[1] The big advances will now be made with computation. What can computer processing power do to improve the images once we have captured them? This has been happening for some time. Think motion stabilisation and portrait modes on your smartphones. The point here is the leaders in this are not Canon and Nikon; they are Apple and Samsung and Google. The consumer's wants drive this, and you can already see the migration to smart photography. Unless it's your hobby, if you are thinking of spending a thousand dollars on traditional cameras, I wouldn't.

What Smartphone Should I Get?

Let me share what I do, and maybe you can build your own system upon this thinking.

My everyday smartphone—an iPhone 13 with 256GB storage—is for running my business and making videos when I'm out and about. It's too much hassle to keep taking it in and out of the studio setup where 9/10 of my videos are made. So I bought a second smartphone to use as my dedicated studio camera. It stays on a tripod and stays powered 24/7 365 days every year. So easy and so inexpensive. You do not need the latest phone to get great-looking results. You need to know how to use it. I have two studio smartphones, both are iPhone 7 with 128GB storage. You can buy these, second hand, for a few hundred dollars. Try for yourself right now. Type into your search bar: *iPhone 7 128GB refurbished price.* There's little that can go wrong with the cameras. I have had mine for three years now, and I have no plans to change them. Plus, every time you update your phone, you upgrade your video system and add an extra camera to your stable.

What about Samsung, Huawei, Oppo, Xiaomi, LG, Motorola, Sony, Vivo? They're all good. Stick with what you know. As a rule of thumb, if the camera gets comparable reviews to an iPhone 7 camera, then it will do the job well for you.

7 Minutes and a Box of Tissues

If you aren't sold on the idea that smartphones can deliver quality, I've got some short videos for you to watch. The first is a beautiful, beautiful short drama called *Daughter*, shot on an iPhone 11 by Oscar-nominated filmmakers. It's seven minutes long and you might get a little choked up watching, so keep tissues nearby.

Then there are two short travel videos and a promotional video I shot on smartphones. Of course! The only cameras I own are smartphones.

If you've already got another type of video cam-era or you simply don't want to use a smartphone, know that it makes no difference to me or your clients. Camera technology is not, and should not be, your stumbling block. Whatever your camera choice, let's get ready to shoot.

Watch the videos here

* * *

> " His techniques, tools, tips and talent truly make him " world-class. Your time spent with Julian gives you an unfair competitive advantage
>
> Keith Abraham, Global Keynote Speaker

Get Ready

*The best time for a map is before
you go into the woods*

Checklists Matter

Fighter pilots from Australia, Singapore and the USA gathered around the back of my car.

'This is Squadron Leader Anderson, Flight Lieutenant Kayo, Captain Sanchez.'

'Hello, hello, hello'. I was at Amberley Air Force base in Australia to film a preview of an upcoming airshow.

We went over plans for videoing that day. I always enjoyed working with the military because they approached the job the same way I did: as a professional. 'Let's get on with it shall we?' In full view of these top-shelf professionals, I opened my camera case. A dozen fighter pilots stared at an empty Styrofoam cutout where a camera should be. I had forgotten to pack the camera. I still get a knot in my stomach reliving that day.

I got lazy. I thought I was too good to need a checklist. Let's learn from pilots. They use checklists every day. I do. You should too. Five minutes making one now will save you countless hours of reshoots in the future. Reshoots cost time and are emotionally draining. Avoid reshoots.

Byte Flight Bright

This simple formula turns a smartphone into a video camera.

BYTE is for Gigabyte. Do you have plenty of storage space on your phone for new video files? Do you have 14,000 must-have holiday photos stored on your phone that are taking up your available storage? I would feel nervous if I didn't have a minimum of 10GB available. I like to go into a recording session with 50GB available because I then feel relaxed. If I'm relaxed, I present well.

FLIGHT is for flight mode. Nothing ruins a good video more than a phone call coming in during a video recording. Switching to flight mode is the easiest way to let your phone act like a camera until required otherwise.

BRIGHT is for screen brightness. We all dim our phone screens to improve battery life, but to make videos, we need bright screens to get our pictures looking their best. Put your screen brightness to full.

A Question of Quality

There's an outdated business maxim that goes CHEAP FAST GOOD: Pick any two. You can have it cheap and fast but it won't be good. You can have it fast and good but it won't be cheap. You can have it good and cheap but it won't be fast.

There's a similar video dilemma we constantly face; we want our videos to be the highest quality and we want our customer/client /staff to see your video as fast and as easily as possible. What's the problem? Can't we just have both?

Video is data-hungry. The better quality your videos are, the bigger the video file sizes become. In a perfect world of fast upload and download speeds, this wouldn't matter. But big files on slow internet means long transfer times. A customer with slow internet might lose interest and with a swipe of the finger, you are digital dust. It's important to get a working understanding of file sizes and formats.

What Format Do You Want That In?

There will be times that someone will ask you: *What format do you want that in?* It would be like being asked, "Do you want that WORD document in .doc or .docx, or would you prefer I send it in a .pdf?" If you have no knowledge of video files, no IT people to ask, no interest in even understanding video, then at least know this: if you are asked, 'What format?', reply... *mp4 H.264* If you are creating a video yourself and you have options available, choose *mp4 H.264* as your finished format.

This will give you the best chance of your video being compatible with other people's desktops, laptops, tablets and smartphones, and it will give you the most hassle-free way of uploading to video platforms like YouTube and Vimeo. This is 2022 I am writing this. Who knows what tomorrow holds? Stay in the know by joining the New Video Professionals Club.[1]

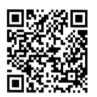

Join the New Video Professionals Club

ASPECT RATIO

Remember the last time you sorted your bookcase? You pulled everything out and halfway through the re-stacking of the shelves, stage you thought to yourself, *Why don't they just make books one size?* You tried stacking by height, but that one book was too big and you had to lay it sideways.

Video aspect ratios are like that. One size would be helpful, but we have 16x9, 4:3, square, letterbox, cinemascope, widescreen and more. For business video, there are three you need to know about: 16x9, 'vertical' and square.

ASPECT RATIOS

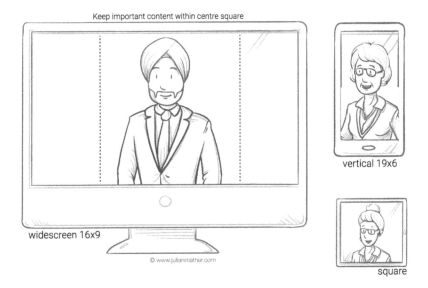

widescreen 16x9
vertical 19x6
square
Keep important content within centre square
© www.julianmather.com

16x9 The widescreen TV most people have in their home and most desktop screens are designed to show 16x9. It is commonly called widescreen TV. Your smartphone is set to a 16x9 aspect ratio as a default setting. So this is a great start. If you were to leave it at default, it would all work nicely for you.

VERTICAL People's video-ing habits have changed since smartphones arrived. Smartphones are designed to be used in one hand. The natural and comfortable way to hold a smartphone is by the long sides. Out of convenience, users began videoing with the phone held vertically. Initially, this caused concern because the video world was set up for 16x9 widescreen, but the people spoke; 72 per cent of millennials won't turn their phone sideways to watch widescreen videos.

The social media platforms changed their system so the vertical videos could be played back in the same way they were shot. This has become very popular because instead of a horizontal 16x9 video taking up just a small percentage of the smartphone screen when held in the com-

fortable user-friendly vertical mode, it now takes the entire screen. More video bang for your buck.[2]

SQUARE Then other social platforms like Instagram poked their square nose in and demanded all videos uploaded to their platform be square. You could upload 16x9 and 'vertical' videos, but they would brutally chop the offending parts off to fit in their square ... and when I say square, that's sort of square ... these dimensions vary. So now an on-line argument rages about which is the best, the most appropriate, the logical winner-take-all aspect ratio.

On one hand, 16x9 mimics how our horizontal set of eyes sees the world; we see in 'landscape'. Younger people simply won't turn their phones sideways. But traditional TV, desktops and cinemas won't suddenly change to vertical screens. Our video bookcase suddenly just got messier. All three are here to stay in this cultural clash.

What Aspect Ratio Should I Use?

Who is the intended audience for your video? Most business videos are viewed in 16x9 horizontal. What if you want the one video to service multiple end-users? Right now, square is the closest to a one-size-fits-all solution. You need to do a small amount of pre-planning. Shoot your video in 16x9 horizontal but keep all your important must-see content towards the centre. You can use a simple editing app on your phone to make a square copy. Now you have the original 16x9 and a square version for the appropriate platforms. That is what I do.

Resolution

When you are printing a page on your home printer, you have to choose the print quality settings. Low|Medium|High| Photo Quality. Same for making videos. You can choose the quality settings, more correctly called resolution settings.

480p Standard Definition (SD) | 720p High Definition (HD) | 1080p Full High Definition (FHD) | 4K Ultra High Definition (UHD) | 8K Full Ultra HD are the common video resolutions. Confused? Don't be. Just do this: in your video settings, look for 1080p 30 fps (frames per second). Choose this option. You'll be good to go.

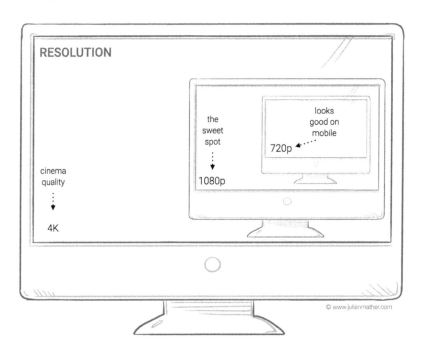

A Trap for Young Players

A trap for older players actually. You may be lured by the amazing quality that is 4K. It is cinema quality and you have it on your phone. It is really, really sharp. It means your wrinkles will be really, really sharp. Just saying.

Filmic Pro

Learn more about Filmic Pro

If you are using a smartphone, iOS or Android, there are two apps that I love. I use them many times a week. Filmic Pro gives your smartphone the level of control you would expect on a professional video camera. Filmic Remote lets you use one smartphone as a remote control for your other smartphone/s. They are not expensive. They will make your life easier. I recommend them to you.

DIY Studio Short Cuts

Given that most of your videos will be you presenting, unless you plan to record your videos out and about in different locations, you will require a studio space in your home or office. The variations from tiny to enormous, budget to hi-spec, are endless. Here are four ideas to get you started.

Green Screen

I steer away from green screen because it adds an extra layer of tech and requires processing power on my computer but it can be the perfect solution too.

Why green? That's the colour that is found least in the human body. This is important as whatever app we choose will remove anything in the picture that is green and replace it with another picture of your choice. If you have green eyes, you may have to tweak the settings.

Even though they are inexpensive, you do not have to buy a commercial greenscreen. Green bedsheets work. Green paint from the hardware. A sample pot is likely all you need. Your green screen doesn't have to be large. Typically 158cm x 150cm works well for a single presenter.

Busy Busy Busy

If your background is cluttered you can declutter it and possibly end up with a tidy but dull background. Try cluttering it up with things that reinforce your message or personality. Books, lots of them, some spines out, some covers out. Knick knacks, curios, photos, awards. Choose a colour theme or go rainbow. Whatever you do, go hard. Half-hearted doesn't work.

The False Wall

I drill holes and add screws without batting an eyelid. I know that it is easy to patch and repaint a room so it looks better than before I started. I have learned through my video coaching that many people don't share this view. For them, and maybe you, the false wall can work well. It is permanent and strong but pulls down fast without leaving a mark. You'll get the idea from this picture.

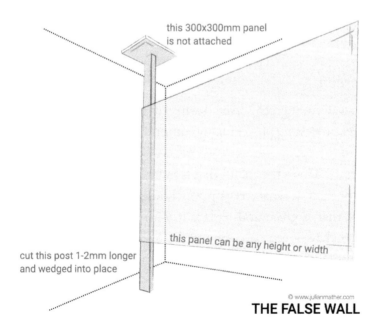

this 300x300mm panel is not attached

this panel can be any height or width

cut this post 1-2mm longer and wedged into place

© www.julianmather.com

THE FALSE WALL

You need two posts. These are typically house framing studs 70x35mm. The length is dictated by your floor to ceiling height. Most hardware stores carry these. They are cheap as well. Get two 30cm x 30cm panels of wood about 12-20mm thick. Place one 30cm x 30cm panel on the floor where one side of your false wall begins. Precisely measure the distance between the ceiling and the top side of the panel on the floor. Add 2mm to the measurement. Cut your 70x35mm framing stud to this length. Now get someone to hold the 30cm x 30cm panel in place of the ceiling and wedge the framing stud under it. As it is 2mm too long, you gently tap it into place. The wood panel spreads the pressure across your ceiling and you end up with a temporary wooden post that is plenty strong enough for our light needs. Repeat for the second post on the other side of the room.

Now screw/clamp/attach some horizontal wooden rails between these posts. Attach lightweight plywood panels to these and paint/cover with fabric or soundproofing tiles. You can add light strips, extra panels with lights behind them, cut out your logo and light from behind. You can create a very professional looking studio set for little cost.

Stuck in a Corner

Maybe the only option you have is a corner. Set up your camera and frame the shot. Using sheets of paper/cardboard and some tape, start testing some geometric patterns like in the picture. Mark the lines and use masking tape to get straight edges on your final painting. Add some small shelves with curios. The geometric pattern tricks the eye and it looks like you are standing against a flat set rather than looking like you are stuck in a corner.

There is so much we can do with colours and lights and materials that are beyond the scope of this book. If you'd like one-on-one mentoring with me, just ask.

STUCK IN A CORNER

© www.julianmather.com

Write a Video Headline

There's a lot of useful ideas in this book. On the surface, it doesn't seem like it, but I think this could be the most useful of all. One of the most valuable video habits to you is having a robust filing system. What do you call your videos and where do you keep them? It has taken me forty years to understand this: before you press the red button, write a video headline. Why? Because making videos requires many moving parts. Video files, editing files, music tracks, graphics, scripts. Keeping them all in one place is easy. Finding them again can bring you to your knees.

For many years, I would quickly name video files as I was creating them, often using shorthand because I was impatient. These videos would go on social platforms, on blogs, and on websites. I would create a folder with a shorthand descriptor of the post name and include a

copy of the video there. Add to that, I randomly updated and changed headlines.

Weeks, months, years later I might need to repurpose a video. The truth is there are some videos that I have never found to this day. I have wasted countless hours searching for them. I don't have this problem now that I write the headline first. Even when I'm in a rush I create a master folder and write a simple, clear, keyword-focused headline and that becomes the only name I use for every component part of that video. The music, the graphics, the video all have the same name. If I change the headline, I create a copy of the entire folder and rename it with the new headline. Sure it takes time, but it is nothing compared to the time lost looking for files.

Not only do you get robust filing, your titles out of the way and some SEO, you also get the first line of your video pre-written. This is a huge time saver. For example, if this section was made into a video, I would write the headline *How to Write a Video Headline.* The first line of my video script would be: *Have you ever wondered how to write a video headline? In this video, I'll share why it's such a good idea.* And there is an extra bonus built-in for you. When this video is transcribed to create video captions, the text *How to Write a Video Headline* will appear as I speak. Captions improve a video's searchability. You get an extra SEO boost.

Writing a video headline is such a good habit. We will start the next chapter with another money-making video habit. It is the very first thing I do every time I shoot a video.

* * *

66 Your Business Video Bootcamp course is truly one of the 99 best courses I've ever seen. I tell everyone I meet to do it so they can learn how to make great videos to leverage the work they do.

Ed Cunningham, Senior Leadership Expert, Sydney

E20 PRODUCTION

Although the photographer
and the art thief were close
friends, neither had ever taken
the other's picture.
-George Carlin

Presenter

Get face to face with clients

You've got a script. You've got a smartphone. You've got a smile. If you can show up on video confidently and you have the know-how to get your message out to the world any time and any place then, you have a distinct advantage over those who don't.

Listen For, Look Out, Lock Off

Listen for background noise. Poor sound quality will lose viewers long before poor picture quality. Before you even set up your camera, listen for noisy air conditioners, people talking, cars revving, radios playing. Try to reduce background noise. It is easier than fixing it in editing. If there is no option but to record in a noisy spot, then let me see the source of the noise and I'll forgive you the noise. If you have to go with it, noise reduction software can help afterwards. It is getting amazingly good. Check out the Krisp app. I've linked to it on the resources page.

Look Out. If you are inside and have no lights or no idea about lighting then look out towards a window. You want to be looking towards the brightest light source. Typically this will be a window of sorts. So the camera will be placed between you and the window. You will be looking at the camera with the window framed behind it. The brighter light will fall nicely on your face. You are the most important part of the shot

and you want to look your best. Don't worry too much about the background. Just tidy it up a bit.

Lock Off your camera. Lock-off is video jargon for a steady shot. Handheld selfie videos are great for fun or if you have a clear reason to handhold. Remember our video secret: distractions dilute your message. Shaky video and moving backgrounds distract. So lock off your tripod. Don't have one?

Tripod Alternatives

The easiest way to get your smartphone to eye level is to place a chair on a table. Now stack books/boxes/pots on the chair. Use a sandwich bag one-third full of rice as a smartphone beanbag to easily adjust the camera angle. Try these too.

TRIPOD ALTERNATIVES

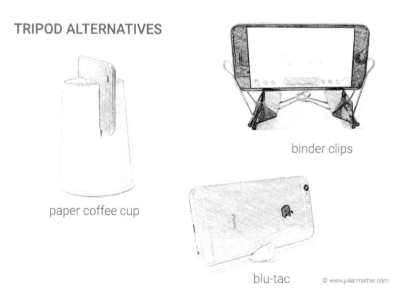

binder clips

paper coffee cup

blu-tac © www.julianmather.com

Before You Buy a Microphone

Ask yourself two questions: 1. Can I quieten the background? 2. Can I move the microphone closer to my mouth? Microphones can help to a point, but a great quality microphone in bad conditions is no better than a poor quality microphone in great conditions. A smartphone, at about an arm's length away, in a quiet room, works well.

The Magic Microphone

How can you get professional-quality sound on your videos without a microphone? Imagine you are at an event. It's noisy. You feel inspired to create a video. Ask to borrow a second smartphone. Designate one smartphone the camera, the other the microphone. Start recording video on both smartphones with you clearly in the frame on both. Clearly clap your hands. Just one clap. Keep recording. Grab the 'microphone smartphone', walk out into the shot of the 'camera smartphone' and freely walk anywhere - near or far - using the 'microphone smartphone' just as a TV sports reporter would use a microphone. When you've run out of words stop recording on both devices.

Now using any simple editing app, import the two videos from the two smartphones and put each on their own track. In both videos, there will be one frame where the hands come together. Sync the tracks together by lining up the hand clap. This is very easy to do. Turn off the sound on the 'camera smartphone' track and turn off the picture on the 'microphone smartphone' track. Export this as a new video. You now have professional-quality sound on your video. This works because the microphones on smartphones are terrific if used well. I've done many videos like this that have generated me income.

Broom Boom

Don't want to hold the 'microphone smartphone' in your hand? (No one cares by the way. No one has ever mentioned it to me.) You can

make a BROOM BOOM. Rubber band the 'microphone smartphone' to a broom handle. Have someone stand on a chair - out of frame - and hold the broom horizontally - just out of frame - above your head. If you see *boom swinger* on movie credits, this is what they do.

The Magic Light

Let's stay at the event described above. You're sounding good but the lighting is less than good. Put a smile on your dial and ask a few nearby people to shine their smartphone torches on you. This works really well.

Tip: The scene above with you, people shining lights on you, someone next to you holding a broom over your head makes a great social post about *teamwork*. Get one person to capture this in a wide shot and when you post, give me a shout out @julianmather.

Level Locate Lock

Level. When we talk to each other, we try to match our eye levels. We both stand or we both sit. It's what humans do. Same on video. When presenting to the camera, place the camera at your eye level.

Locate the lens. There is only one place to look when presenting—straight down the barrel of the lens. The lens is easy to find on the back of a smartphone. What about the selfie camera? I recommend you use the selfie camera. Why? Isn't the back camera better quality? Yes, but selfie cameras have more than enough quality for our needs. If the selfie camera isn't a small obvious dot and you are struggling to find it, then do this. Turn on the selfie camera and with your fingertip, poke around the edges of the screen. When you poke the lens, your finger will loom large and the screen will go dark. I mark the edge of my phone with a dot of nail polish so I always know where to look.

Lock onto the lens. How do you expect to connect with your clients and customers if they can't connect with you? We connect through our

eyes. If you are in conversation to engage someone's services and they never looked you in the eye, your internal radar would beep. This leads us to a problem peculiar to selfie cameras. When we use the selfie camera, our default is to look at ourselves on the screen. That means we are not looking straight down the barrel of the lens and the viewer subconsciously perceives this. They see us looking somewhere, just not directly at them. A very bad technique for building trust.

That's why I mark my lens with a dot. I have a point to focus on. But there is a force stronger than my good intentions at work here. We have been told since childhood to look people in the eyes and engage others in conversation. As I am looking at my dot, there in my peripheral vision is a set of eyes, mine, and like a magnet, they momentarily pull my gaze onto theirs. I dart back to my nail polish dot, but the eyes draw me over again. Now I look shifty, which is even worse for building trust.

Cover your screen. Use a post-it note. A piece of folded paper. A hanky. I have a simple pre-cut piece of card with holes to see my important camera buttons and meters. I secure this with a rubber band. A low-tech, high-value tool.

Framing

There's nothing wrong with placing yourself symmetrically in the centre of the frame. It worked for Mona Lisa; it'll work for you too. Mostly, I frame myself differently. This is what I do and the reasons I do it. I place myself to one side of the frame, left or right, about a third of the way across. I naturally angle my feet and my body follows so I am angled towards the centre of the frame. I leave a gap between the top of my head and the top edge of the frame. This is called *headroom*. Plonk your closed fist, fingers facing the camera, on your head. That's how much space you should have. Another way is to place your eyes on an imaginary line two-thirds of the way up the frame. Framing is more art than science. Just do what I have outlined, and it will work.

FRAMING

position yourself on one of the thirds

a fist sized gap

KEY
GRAPHICS
CAN GO
HERE

eyes on horizontal third

careful your face doesn't end up
behind a play button

the goldilocks zone of headroom

too little

too much

just right

© www.julianmather.com

angle your body

Framing myself to one side allows me to use a lot of graphics and text on the opposite side of the screen. The main reason I put myself to one side, is that other people use my videos and many times they don't use video thumbnail images. That means my face ends up behind the play button; you don't get a second chance to make a first impression.

Focus and Exposure

Have you seen videos where they go in and out of focus as the camera is trying to decide what it should focus on? Other times the exposure pumps light, dark, light, light, dark as the person in the frame moves their head. This is all the result of automatic settings. Automatic works well until it doesn't. The problem with automatic is you are not in control. That is not commercially smart. Use manual settings where you can lock your choices for the duration of your shoot. Remember the Filmic Pro app for iOS and Android mentioned a few chapters back? It is brilliant for putting you back in control. I shoot all my videos with

it. Remember the Filmic Remote app also? It comes into its own right now when I need to relax. It lets me control my camera remotely. I don't have to walk back and forth to my camera to change the focus and exposure.

My Recording Ritual

When I record videos, I'm going from a passive thinking state into an energetic presenting state. I need to be confident. Free of tech worries. Free of worries about my appearance. I developed this ritual to help me get up to presenting speed. It takes about 5 seconds. I do it silently and always in this order.

TECHNICAL

1. Counter counting - I see the numbers on the recording counter increasing. If I see the numbers numerically increasing I am certain I am recording.

2. Meter moving - I see my audio meter bouncing as I speak. I know I am recording sound.

PHYSICAL

3. Slouch un-slouching - In all the thinking about what I am going to say, I tend to lose my upright posture. I sit/stand up straight.

4. Face smiling - It is so easy to forget to smile. I activate my facial muscles. Do I feel I'm happy to be here?

MENTAL

5. Now, what can I do for you? - Points 1-4 are all about me. Now I make the mental switch to it being about the person I am speaking to.

Before I trained myself into this ritual, I would be double and triple-checking the camera was recording; I would fidget and adjust my pose.

When I spoke, I wasn't really there. I was still inside my head. It showed. To this day, I still do these 5 things before recording any video.

Never Memorise a Script Again

You don't have to memorise a script. I don't. I wouldn't make videos if I had to. Nor do I use a teleprompter where I read the words from a see-through screen placed in front of the lens. I just deliver a line or two, maybe a paragraph of my script at a time. Through the magic of editing, it looks as though I did the entire video in just one take. Using this next technique that I call Silence Smile Speak, you will cut down your edit time. Combined with another technique I call Zip It Mark It Crush It, you will become a productivity powerhouse when making your business videos. More on this later.

Silence Smile Speak

Let's take stock of where we are at this point. Right now you are in front of the camera. The room is quiet. You feel some sort of bright light in your eyes. Your script is at eye level, just next to the camera. You've checked your framing. Your exposure and focus are done. You've exhaled deeply. You've pressed the red button. You've done your 5-step recording ritual. Now you have to open your mouth and speak.

> Tip. Make just one long recording of your script with all your good takes and mistakes.

2 Deep Breaths - Slow. Oxygenate your blood. Long exhale.
Silence - Five seconds of it.
Smile - Your energy introduces you before you do.
Speak - Say your words
Hold - On your last word, hold your eye contact with the lens for two seconds. Silence!

REPEAT this process, even if you make a mistake or 5 mistakes. Soldier on through your script.

If you have a script that has ten sentences and you are going to deliver each sentence separately, the best thing you can do, and I say this respectfully, is shut up. Of all the habits I share in this book, this could possibly be the greatest gift for you. If you can master not talking between takes, you will make double the videos in half the time. More on this later.

Mouth Feel

Not all words are created equal. Words that read well on paper sometimes get stuck on the tongue. You will benefit ahead of time if you have 'heard' and 'felt' the words roll around in your mouth, so you know the stumbles that lay ahead before you hit the record button. Do the words 'speak' well? Get into the habit of reading your script aloud before recording.

O.R.O.A.

When I was in the army, I met many people who suffered O.R.O.A. An over-reliance on acronyms. They were sending SITREPS(situation reports) about DZ's (drop zones) to fly in a chopper DUSTOFF (Dedicated Unhesitating Service To Our Fighting Forces) to MEDEVAC (medical evacuation) a casualty. Too many acronyms cause jargon monoxide poisoning.[1] You can suffocate discussion if the people listening are not in on the jargon. Don't leave your video audience wondering because you have slipped into jargon.

Call to Action

You need to nail your call to action. It needs to be clear, precise and very specific. *Click the orange button below this video that says ENROL NOW.* Write out your call to action. Practise speaking aloud the exact words you will use. If you are pointing to an area on your left or right where a graphic will be added during the post-production of your video, be clear in your mind which side it will appear on so you can point to it with ease. I often record multiple CTAs with variations on my instructions. It is always faster than a reshoot.

The First Take Is the Sweetest

Once comfortable, if you deliver a line to the camera without any major stumbles or factual errors, then that is the take that will be used. After decades of working with professional presenters and my own presentation experience, I can report that if you shoot five takes, it is almost always the first take that will be used. The time taken to record the extra takes and the time taken in the edit to compare the takes is your valuable time wasted.

Know Your Last Line

We know how it will start because we now have the habit of writing a video headline, and that can be our default first line. Knowing how you are going to finish is more important. It's more important because beginners overlook this critical step.

When you are delivering the body of your video script, maybe it's point 1, point 2 and point 3. You know the last line to endpoint 3. When you speak it, you stop. Your speaking cadence will feel natural because you have practised the moment. Without missing a beat, you offer your call to action. Not knowing your last line, you ramble. Out it comes. All this fluff and filler while your mind tries to think of how to

end this video. Eventually, you awkwardly run out of words. It doesn't have to end like that.

You Can't Polish a Turd But You Can Always Roll It In Glitter[2]

No amount of clever packaging will elevate weak content. Those days are gone. We're all media experts now. We've all seen it all too often. Shortcuts like this don't work anymore. Throwing production dollars at a weak script is dumb. Your presenting confidence is directly related to how clear you are about your message. The easiest way for you to become a compelling presenter is to work on compelling content.

The Wrapper Matters

Prominent marketer and thinker Seth Godin has many exquisite and pithy maxims; "the wrapper matters" is one. It's worth mentioning here, as there is often a tension between authenticity and quality that takes time for new video professionals to resolve.

In the context of a lot of talking-head style business videos, we remember how people make us feel. We remember the way people say things. We rarely remember the way things looked. Don't kill the authenticity by letting your problem with perfection get in the way.

Be Utterly Compelling

Be helpful. Be consistent. Be humble. Be vulnerable. Above all, be you. If you do that, then, in your own way, you will be utterly compelling to people who want what you have. Authentic video presenting is a superpower in a time when out-yelling, out-interrupting and out-spending your competitors doesn't work anymore.[3] Those who can do it have a distinct advantage over those who can't.

Interviewer

Let Others Talk

I love interviewing because it generates a lot of useful content that has helped my business. Setting up a video podcast is technically easy to do, and it is getting easier. You record a long interview and repurpose that by chunking it down into a bunch of bite-sized videos that work well to post on social media. I love it even though I'm not that good at it. I've certainly been around interviews long enough to understand them.

I have done thousands of interviews where I was behind the camera as a cameraman. I've interviewed hundreds of guests and been interviewed a hundred or so times myself. I still get a few butterflies when I interview others, so I looked to create a process that would make this valuable skill easier for new video professionals.

The Easy Interview Formula

I combined a conversation formula and a technique I used to help me get over my nerves performing magic. You can use this to interview someone for a short video, maybe a podcast, and maybe a live stream on a social media platform.

What kills many interviews is if you keep asking for facts. What happened next? Then what? How many? If the topic only requires these fact-driven questions, then maybe this topic is best suited to a written PDF or blog post.

The F.E.W. formula, from networking specialist Jordan Harbinger,[1] - adds elements that make for engaging conversation: Facts | Emotion | Why. Instead of asking for *fact fact fact*, ask *fact, emotion, why*.

FACT: What happened next?

EMOTION: I would have been scared to do that... how do you deal with those feelings in those situations?

WHY? What got you into that in the first place... it seems an unlikely path to follow?

Now you're having a conversation instead of a series of answers to a series of questions. But I still want a safety net of questions.

Interview Like a Late-Night Talk Show Host

My problem with a list of questions is that I can't listen and keep track of the next question at the same time.

So I added to Jordan's F.E.W. a technique I used when performing magic called HIDDEN IN PLAIN SIGHT; if you want to hide something from an audience, put it right under their noses and they'll never see it. We tend to ignore the obvious.

Instead of a paper list or a digital list on your device, write a list of questions on palm cards. One question to a card. Don't hide them. Instead, make the palm cards a feature. Brand them with your colour. Maybe call them something like THE 10 IMPORTANT QUESTIONS. You'll see late-night TV hosts like Conan O'Brien do this.

Ask the question then shift that 'used' card to the bottom. This way you never have to search for the next question; it's always at your fingertips. Now you can relax. Guess what happens when you relax? You can listen. Really listen. Good interviews are based on good listening, not good questions. Now use the F.E.W. questions to flesh out their re-

sponses. Your palm cards are your safety net in case you lose your way. This way you can be a bit more daring in your interviewing style. Remember, better questions get better answers. Now you can have a confidence-building tool, in plain sight, and your viewers are none the wiser.

Make Them Feel Safe

I have been in interviews where the journalist has gone for a politician's jugular. I have watched people's eyes through my lens as they were left shell shocked and slack-jawed by tough questions. That's not the game we play as new video professionals. We are rarely adversarial.

Guests are nervous enough as they are. It is your job to make them feel safe. You make them feel safe by knowing what you are doing, respecting their time, guiding them through the conversation, laughing, smiling and empathising. What you don't do is tell them what you are going to ask them.

No Pre-Interviews

The surest way to get an average interview is to tell them what you are going to ask them beforehand. People's responses are always the best on the first telling, and their responses become deflated the second time around. In your pre-interview emails, you can outline the general questions. You may have a question you ask all guests like *what book are you reading right now?* You give them those sorts of questions ahead of time. No one likes to be ambushed.

Sit as Close to the Lens as Possible

Where only the interviewee will appear on the screen and you are the interviewer unless you have creative reasons to do otherwise, tuck yourself in close to the camera. This way we see as much of the interviewee's face as possible rather than a more side-on view. Viewers like to see peo-

ple's faces. We like studying people. It's rude to stare in real life so we do it at home from the couch.

Make Them Feel Comfortable

You have to be careful that your desire for high production values doesn't kill the magic. I was guilty of this for years. For much of my early video career, though I professed to be in service of the production, really, I was in service of myself. As a young cinematographer, I had a hitlist of shots I wanted for my showreel. I would have people sit uncomfortably because it looked better. I would have them cooking under lights, and they would accept it because I told them they'd look better. My need to prove myself to my peers suffocated much spontaneity and authenticity. Go easy on your guests.

Sound Check

You need to check your sound levels. To do so requires a good ten seconds of your guest speaking. You won't get that by asking, 'Say something so I can get a sound level.' They will reply, 'One, two, is that ok?' You need to engineer their response. Ask them to start counting 1 to 100 or say the alphabet A to Z. Add, 'With a sense of purpose in your voice,' and you will have a quick, painless sound check.

Make a Test Recording

Wasting your own time is one thing, but wasting your guest's time is not forgotten quickly. Do a test recording. Play it back and check you have focus and the sound is clear.

Framing an Interview

New video professionals don't have multi-cameras and studio crews. We have a smartphone, and we're not afraid to use it. The set-up is simple. If you can, place the host and guest on stools, side by side, with stools angled in towards each other. You get the posture of standing but the comfort of sitting and you don't shift around. Frame your shot from head to waist. Leave some space on the edges for elbows to stay in the frame.

Remember back in a previous chapter we talked about resolution? 4K? Cinema quality? Now is a great time to use it. If you shoot the single shot as described above, 4K has enough quality to allow you to zoom in during editing and just use a single shot of either the host or the guest. To the viewer, it looks like you have used three cameras.

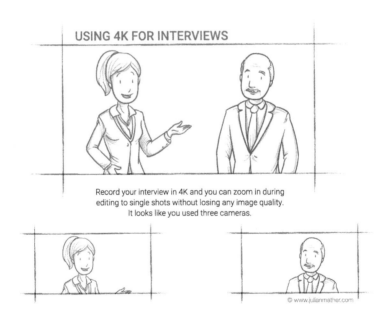

USING 4K FOR INTERVIEWS

Record your interview in 4K and you can zoom in during editing to single shots without losing any image quality. It looks like you used three cameras.

© www.julianmather.com

Remember back in a previous chapter we talked about Filmic Pro? There is another brilliant app called Double Take (iOS only at this time). It lets you record any two of your smartphone cameras at the

same time. You could sit at a table with the host and guest at opposite sides, your smartphone placed on the table between both of you. Using DoubleTake, you could record with the front (selfie) and with the back camera. You can record both cameras in full quality, side by side on the screen or as two separate videos that you can combine in editing later on as you please. The viewer thinks you have two cameras.

Quick reality check: we're doing all of this on one smartphone. Just one. Are you starting to see how new video professionals are leading the way into the future of business videos?

Microphones

Now is a good time to mention microphones. I have one thing to say: RODE Wireless GO. This is the most useful, flexible, reliable microphone system I have ever used. It is a simple wireless microphone that you clip onto your clothes and a wireless receiver that you clip onto your smartphone. You can walk around. No wires.

It comes as also as a twin set so both the host and the guest can have their own microphone. But wait, there's more! For a small cost, you add the RODE Interview GO. It looks like a news reporter's hand-held microphone, but it has no microphone. Instead, it has a slot that perfectly takes the RODE wireless GO microphone just mentioned. Now you

See the RODE
microphones

have a handheld microphone that can be used to interview one, two, three, four or five guests.

The Microphone Is Always On

It astounds me when politicians get caught saying something that gets picked up by the cameras and they say, "I didn't realise the cameras were on." The cameras are ALWAYS ON. You should do this too. Not to embarrass your guest, but the opposite— to make them look good. Most guests are in tension during an interview. They feel out of place. They want it to be over. When you say, "We've stopped recording," they almost always release their tension with a gust of nervous energy that comes audibly from their body. All of a sudden they become animated and it's right about now they say something that is magic, something they didn't think they could say in the interview. Without missing a beat, you keep the conversation going. This is all being recorded because new video professionals are always recording. This is the bit that gets used in a quick promo. This is the bit that makes them look good. This is the bit that makes them remember you.

Don't Step on Words

If you are being interviewed or if you are interviewing someone else; if you are on a panel discussion that is being recorded; if you are in any situation where multiple people are talking and it is being recorded on video, podcast, radio or television, then try not to talk over the other person. Let them finish before you reply. Don't step on the end of their words. Why? Because if you have to edit the recording afterwards, it is so time-consuming to make a cut when two people are talking at the same time.

The Art of Shutting Up

One of the best things I learned from working on a long-running documentary series on Australian TV called *Australian Story* is the technique of saying less to get someone else to say more. This series, now in its twenty-fifth year has no narrator. The subjects tell the story them-

selves. The in-joke on the production team was that there are two times in your life you are allowed to talk about yourself for hours on end: in therapy and in an *Australian Story* interview. Both end the same way: in tears. As you unpack your thoughts and emotions you often start to piece together the puzzle of your life. Insights that remained buried under the steady drum of daily life have a chance to rise to the surface.

During interviews like this, when you ask a probing question and you don't get the answer you expected, the trick is to say nothing. Not a peep. People, as a rule, are very uncomfortable with a long silence, and to ease their discomfort they'll just start talking. They'll start over-talking. It's then that some of their best responses happen. A lot of the stuff they've been holding down just bubbles up.

Statement or Question

You may be making a training video or an explainer video. You are interviewing someone but you will not be appearing in the video. In this situation, you prompt your guest to answer with a statement. They do this by including your question at the start of their answer.

As an answer: Q. What is your favourite colour? A. *Red*
As a statement: Q. What is your favourite colour? A. *My favourite colour is red.*

As an answer: Q. What is key learning in this process? A. *Click on B before clicking on A*
As a statement: Q. What is key learning in this process? A. *The key learning in this process is to click on A before you click on B.*

A statement gives context. This will speed up your editing manyfold. Are you beginning to see that so much of what we do is to speed up editing? The same goes for shooting B roll; it's all about the editing. Let's shoot some B roll.

Reporter

Show Us What's Happening

A reporter acts as our eyes and ears. They go somewhere to tell and show us what is happening. The presenting and interviewing skills you have just learned allow you to tell us what is happening. It's time to learn how to show us what is happening.

First, what to shoot?

Coverage

Got coverage? This is the question crews ask before they leave a scene. Have we got all the component parts we need to make our story before we depart? This isn't film school; it's *Press the Red Button*. What do you need to know so your business videos don't come home empty-handed?

Rudyard Kipling, the author of *The Jungle Book*, used a set of questions to help trigger ideas and solve problems, and he immortalised them in a poem:

I have six honest serving-men
They taught me all I knew
I call them What and Where and When
And How and Why and Who

Just ask what/where/when/how/why/who. Stick this in your back pocket for when you need it and you'll rarely come back with missing shots.

Shoot Show Shift

What follows was the genesis for my concept of E20 Video Skills. In a moment of reflection, I wondered if I was given just one minute before I died to tell you what I knew about shooting video, what would I tell you? I like challenges. It took me a year to boil it all down into these nine, simple essential elements. I am so sure of this I can confidently say, if you follow these nine steps, that with a bit of consistency you will shoot like a pro and editors will love you.

If someone asks you to video an event, a meeting, something at your workplace, a social picnic, anything, instead of just pressing record and aimlessly wandering around pointing the camera at whatever is happening, do this...

Shoot a wide shot
Shoot a mid-shot
Shoot a close-up

Show where we are
Show what's happening
Show who's reacting

Shift up
Shift down
Shift in

Shoot a wide shot

Shoot a **wide shot** of whatever is taking place. If it's in a park, go to the other side of the road and show the park. If it's in a warehouse, climb the stairs to the mezzanine level and show the warehouse.

Shoot a Mid Shot

Shoot a mid-shot of everything that is happening that is of interest. If it's a sausage sizzle, get some shots of people cooking and people in a group eating. In the warehouse, get a shot of the forklift lifting a palette or boxes being unloaded from a truck. Get lots of mid-shots. Let us see *what* is happening.

Shoot a Close-Up

Shoot a **close-up** of the most interesting parts of the mid shots you just videoed. At the sausage sizzle, get a close shot of sizzling sausages. Get a close shot of sauce squirting onto the bread. Get a close shot of the park sign. In the warehouse, get a close shot of the forklift driver's face. Get a close shot of the hands lifting boxes. Get a close shot of safety harness buckles clipping in.

If you just keep saying wide shot, mid-shot, close-up in your head, over and over and over as you are videoing, you will improve your video camerawork a hundred-fold. I'm not exaggerating. You will speed up your editing time ten-fold. I'm not exaggerating. You don't need to shoot in this order. Just grab plenty of wides, plenty of mids and plenty of close-ups whenever you can.

The next step is to add some storytelling into your mix of shots. People love stories. Storytelling is key to marketing, branding and communications. Embedding storytelling into what you shoot is easier than you may think.

Show where we are

Have you noticed sci-fi films often start in star-filled space; Westerns in deserts with cacti; urban stories flying over concrete canyons of sky-scrapers? Showing us where you are is a time tested way to start a story. It anchors us and provides context for the characters. So, show where you are. This is best done with a wide shot. Hey, didn't we use a wide shot earlier?

Show what's happening

There are some basic physics attached to storytelling: action and re-action. Action by itself is energetic. People reacting to actions is dra-matic. Start by looking for the action. What's the reason we are here? What's the most interesting thing happening? Generally, these are self-evident. This is usually depicted using a mid-shot. Hey, didn't we use a mid-shot earlier?

Show who's reacting?

Who's reacting to the interesting things that are happening? Faces. People looking. People taking notes. People laughing. People disagree-ing. This is usually depicted using a close-up. Hey? Didn't we use a close-up earlier? Sure did. Now when you are getting wide shots, mid-shots and close-ups you can be thinking about adding story to them with location, action and reaction.

Shift Up

What's remarkable mean? Something that is worthy of you remark-ing upon it. If you were the one person who did something different to ninety-nine others, that would be remarkable. Here's how to make re-

markable videos: move your camera away from your chin. Ninety-nine per cent of the world's population shoot their videos from around chin level because that's the most comfortable way to hold a camera. So shift. Start by shifting up. Get a high shot. Stand on a ladder. A chair. Look down from the stairs. Extend your smartphone on a simple selfie stick above everyone else's heads.

Shift Down

The world looks so different to an ant. We don't see it that way because it hurts our knees. Get some low shots now and then. They are even more remarkable than high shots now that every teenager has a drone and overhead flying shots are losing their impact.

Shift In

Out of all the shifts, this is the most important. Shift in. Get close to the action. Get into the ringside view of life. Let me feel the emotion, see the sweat, smell the fear. It may be a little extreme for business videos, but you get the idea. Standing around the outside walls of a room only gives you wide shot after wide shot with tiny people. Walk in. People don't mind. Smile. Say thank you. There's one more reason to walk in. It's the reason documentary makers use wide-angle lenses that force them to get in close to the action and to the people. By walking the camera in closer, you are also walking the microphone (on the camera/smartphone) in closer. Record what people are saying; the dialogue is so useful, even if you don't have the vision of them saying it. In the editing room, good editors can save a story by just having the dialogue.

Those nine steps have accounted for probably 99% of everything I have shot for 40 years. They have worked brilliantly for me. Try them. Maybe you won't? Maybe video making still feels intimidating. If that sounds like you, then try this instead.

SHOOT SHOW SHIFT
shoot like a pro

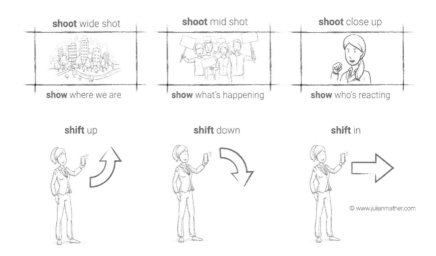

shoot wide shot

show where we are

shoot mid shot

show what's happening

shoot close up

show who's reacting

shift up

shift down

shift in

© www.julianmather.com

Walk Talk Twist

Reporters tell us and show us what is happening. What great skills to bring into our daily routines. We all love to be updated, to be kept in the loop, to feel we are valued and respected. Walk Talk Twist works brilliantly to reassure clients and coworkers that everything is under control.

Imagine a client is visiting your office, and you want to explain to them where the keypad to the car park is located and that there is a great coffee shop just around the corner. You could write a convoluted email or you could do this...

Attach your smartphone to the simplest, cheapest selfie stick. Go into selfie video mode and press the red button. This next bit is counter-intuitive. Extend your arm with the selfie screen away from you. You will be looking at the back camera. If you hold the smartphone fairly level and square onto your body, you will be in the middle of the frame. Try it and see. Now start speaking to the camera; all your presenting skills are valuable now. Explain that they need to use the keypad. By

now, you are standing opposite the keypad. Use your thumb and fingers to roll the selfie stick handle and rotate the smartphone 180 degrees. Just a simple half twist. It should take you all of half a second to do.

WALK TALK TWIST

Now you are looking at the selfie screen and can clearly see the keypad as you are describing it. This is why we started with the selfie screen away from us. We can now see what it is we are talking about, which makes for much clearer videos. To the client watching the video, the half-second rotation looks like an editing effect. At any time, of your choosing, you can rotate the camera between your face and what's in front of you. You are creating edit-less editing between shots. This way you can create a very clear, informative and personal video, which goes such a long way to building your brand because you have taken the time to show up on video to help your client. That's powerful.

Storyteller

Stories Are Serious Business

Did you ever have a box of blocks as a kid? Did you ever build a block construction and it was going so well until you discovered you were missing one piece? It's then that everything ground to a halt. Editing is like that. Editors work fast until the shot they need isn't there. Production slows as they think of a workaround. That costs you money. It's so much better to give them all the shots they need.

The techniques that follow will give you more control over getting B roll—the pictures that illustrate the A roll. The simple techniques that follow will give the editor more options. Editors love options. More so, they need options. Their choices can make the story go in any manner of direction. They are storytellers more than editors. They are better storytellers than most new video professionals will ever be. We've arrived at a fork in our video road.

A Fork in the Road

New video professionals must present. Your business depends on it. It's not much of a leap to be able to interview and create more valuable content. At some stage, you'll find it faster and easier to show someone rather than tell them. That's where reporting comes into its own. The truth is few of you will become good at video storytelling. Storytelling is more art than science. Getting good at it takes time. If you're running a business, time is always scarce. The fork in the road is for us both. If

you want to be a filmmaker, then I'm not the person to get you there as it's here I recommend you plan to outsource your editing. I will teach you some great editing disciplines in the coming chapter. I will introduce you to edit-less editing options. There are so many people who can edit so much faster, so much more creatively and so much cost-effectively than you, that it makes no sense for you to do it.

B Roll Money Makers

These are reliable video habits that will help you consistently create B roll that will give editors the options they need to work faster so you spend less.

Be Direct and Direct

I was a few hundred magic shows into my two thousand magic shows that I ended up performing when I learned something curious about audiences: they're happy to be told what to do. We spend our days and weeks making decision after decision. If you find yourself sitting in an audience and the person onstage wins your trust, you will give yourself over to them for the duration. Why? Because you don't have to think. For half a glorious hour, you can give your brain a rest. The same is true for directing people when making videos. They respond to competence and respectful authority. You don't have to be an expert. Just knowing Shoot Show Shift from the previous chapter will make you look masterful. Starting by having the talk.

Having the Talk

Where possible, I always call people in. I start smiling. I'm already recording before I speak my first word so this is all captured as a record of the conversation.

I'm Julian Mather, and I'm making a video here today, and I want you all to be in it, and I want you to look your best. There are two things that will make this go smoothly and make me disappear out of your life faster... you're interested now, aren't you?

First, please tell me now if you really don't want to be on camera. Again, I'm only interested in making you all look good today. [Brief explanation of the purpose of the video.] Anyone? [One person objects] Ok, sir, can I get a brief shot of you on video now just so the editor who is hearing this can avoid any shots where I might accidentally have you included? Thanks. Anyone else?

The second thing is please ignore me. If you suddenly notice the camera pointing at you, don't duck down and try to scuttle out of the shot. In my experience, there's nothing that brings attention to someone more in a video than when they are ducking and scuttling out of a shot. Just ignore me. I'll move on. Thank you.

People respond really well to me after this. I have shown my credentials. They feel they can trust me. Just like in the magic show, they are happy having one less thing to think about.

Horizontals

Throughout life, we are accustomed to horizons and bodies of water being horizontal. Keep an eye on your horizontals and verticals in your shot. Choose one horizontal or a vertical, and square your framing to that. This will become instinctive.

5P5

Wide shots and mid-shots don't have to be static. You can make them move with pans and tilts. Panning is a horizontal movement across the scene. Tilting is an up or down movement. Every time you do a pan or a tilt, you say 5p5 to yourself. This reminds you to start with a 5-second long static shot, then make your pan or tilt to stop at another 5-sec-

ond static shot. Instead of creating one moving shot, you have created 3 shots: two statics and a move. You have given the editor choice.

Enter Frame Exit Frame

If you are setting up to shoot a person, an animal or an object moving across your frame, where ever you can set it so they/it starts outside the edge of the frame unseen, enters and moves across the frame to eventually fully exit the frame on the opposite side. You have again created three shots where you would have had only one. Editors love enters and exits and, by the way, at this stage, editors are loving you too.

Enter and Follow

This is a variation on Enter Frame Exit Frame above. Let's say you see a car coming and you quickly reposition your frame ahead of the car and let the car enter the frame. As it moves across the frame, you pan with it. By doing this, you reveal where it is going. Use this in conjunction with the next habit.

Stay Buttoned on for Sound

Whenever something that is making noise is about to enter the frame, try to start recording ten seconds early, and whenever something making noise exits the frame, try to keep recording for longer. The sound before and after you see 'it' is so useful for editors. This sound can be added over the preceding or trailing pictures to great effect. In life, we hear things coming before we see them. We hear things long after they leave our view. So keep recording longer for sound. Note: *buttoned on* is a film jargon for recording.

The Reveal

If there is one shot that packs a big bang for the buck, it is a reveal. Imagine, the camera flies over the rugged forest and Hawaii reveals itself as the green of the mountain ridge gives way to the blue of the Pacific. You get the idea. Here's a simple reveal I have used hundreds of times indoors. One room is where the action is. It could be an office full of people at workstations. I co-opt a willing assistant and work out timings with them. I go to an adjoining room and close the door. On our pre-determined signals, I start moving towards the closed door, the assistant on the other side opens it just in front of me and the busy office space reveals in front of me. This can look quite dramatic. It works best with a wider angle lens. Most newer smartphones have excellent wide lenses. Note: get the timing right with your assistant or ...*ouch!*

Living Titles

The power of video is that it is moving pictures. Take advantage of this where you can. Whenever you are shooting, be looking for variations of your shots that would be useful for adding titles or graphics. Maybe you are getting shots of the city. Frame an extra shot that is almost all blue sky and the city buildings only on the lower edge of the screen. Record thirty seconds of this. These are much more interesting as backgrounds for messages you might want to display. You can build your own library of these. Super useful.

LIVING TITLES

look for framing variations that
allow you to add text or titles

ADD TITLES
HERE

© www.julianmather.com

Atmos

For every location you shoot in, you must record *atmos*. That is short for an atmosphere track. It is thirty seconds of nothing but background noise that can be used by editors to disguise differences in background noise levels between various shots. In my pocket, I carry a small card with the word ATMOS written. I frame this in the shot and press the red button. I call out QUIET FOR SOUND and everyone must be quiet. No moving, rustling, talking as I record *atmos*.

Signs

Signs are really useful to show where you are, where you've been and where you are going. They take a few seconds to grab and can be life-savers in the edit.

60-Sec Safety Shots

Get a 60-sec shot of every person you think might be important to your story. They can be doing anything. Sitting, talking, walking. As situations change, your story may change. Someone who was more of a background player may become a new focus. You can always narrate a new A roll script and use your 60-sec safety shot as the B roll. Unless you have a crystal ball that works, this is a good habit to have.

Video Is Modern Magic for Business

Here's a parable: Two young fish swim along, and they happen to meet an older fish swimming the other way, who nods at them and says, "Morning, boys. How's the water?" And the two young fish swim on for a bit, and then eventually one of them looks over at the other and goes, "What the hell is water?"

When we grow up immersed in some*thing* so fundamental to our existence, that *thing* can easily escape our conscious attention. The language of film-making falls squarely into this category. What you can do with it is magical, and it doesn't cost a cent to do. The reason it works so well is because of what I call the 9-Year Curse.

The 9-Year Curse

It's safe to say that almost every living person has seen a movie or a video. The average TV/digital viewer watches 3 hours a day.[1] This is a beautifully benign statistic because it doesn't sound bad, does it? Let me repackage those figures for you. That's 45 full (24hr) days of non-stop TV viewing a year. By the time you are 70, you will have spent 9 whole years of your life sitting on a couch watching a screen. Have you picked yourself up off the floor yet? None of us would map out our life to include these 9 years, yet somehow it has become the norm.

Those 9 years program us to accept that magic is real with the four edges of the screen. One moment a character in New York looks at an

Air France plane ticket sitting on the desk and the next moment that character is walking below the Eiffel Tower. A woman sits on the porch with a pile of letters in her lap; she stares, lost in thought. Suddenly she is seven years old again and running through a field. On the screen, we time travel, we cross galaxies, we die and come back to life and when it happens, we don't bat an eyelid. If anything like this happened outside the edges of the screen, your eyes would be like a crab, out on stalks.

Filmmaking lets you compress time. I know lots of businesses that would like to save time. Knowing this lets you craft videos to focus attention. I know lots of businesses that would like to get people's attention on the right things.

The humble cut that joins two shots—where one finishes and the other begins—is so powerful, yet in an age of digital effects, it is so overlooked and under-appreciated. Here are two practical applications for you.

The Magic Cut

How could you bring your office, your community, and your association together when they are miles, even nations apart? How could you BE YOUR BRAND by showing the world people like us do things like this? How could you do it with just a smartphone and the most basic of editing techniques: the cut? This is so easy to do yet so hard to explain. Once you see it, you will get it immediately. There only needs to be one common thread of connection that is clear to the viewer and then the magic

Watch the Magic Cut and Magic Conversation videos

of film-making begins. Watch this video of some examples I collected during the Covid-19 lockdowns.

The Magic Conversation

Write a simple script that has a dialogue between two characters. You then act out each of the two characters. When cut together, our minds offer no resistance. We engage with the story and the message. It's fun to do and engaging to watch. You can shoot it in one room. Change clothes to match the characters. The video shows you how powerful this can be.

The Magic Point

You may have heard the term *misdirection*. It refers to how magicians direct your attention onto something so elsewhere so they can do a sneaky move. It is poorly named. It should be called *direction* as it is directing your attention. The most powerful misdirection is the simplest. You will look to where I look. You will look to where I point.

Use this technique to get attention to your key points. Casually look and point to a word as it appears graphically beside you as you present to the camera. Your viewer's eyes and attention will go to that word. Evolution has pre-programmed us to do this. No one wanted to be the person who didn't see the sabre tooth tiger coming from the bushes. Now you know it, so benefit from it.

CVO: Chief Video Officer

Here is something to consider: a small to medium-sized business could easily spend an employee's wage on outsourced video production. I would consider getting someone with energy and youth, who is already making videos to read this book. If the message within the pages resonates with them, then I would consider hiring them as your CVO, your chief video officer. They would be the perfect solution for what I am suggesting in the next chapter.

E20 POST-PRODUCTION

I shoot people and cut off
their heads.
—Photographer's job
description

Editing

The Art of Anti Editing

I've edited thousands of videos, but I would never call myself a video editor. I'm not interested in video editing per see. I'm interested in getting useful, commercial content out the door because that's what new video professionals do. Here are the two editing shortcuts that enable me to do it.

Zip It Mark It Crush It

Zip It Mark It Crush It has the potential to save you countless hours, which translates to big productivity gains in your business.

Clients will often confide in me - after we have been talking for a while, and they know I won't judge them. Sometimes they spend hours making a one-minute video. They are usually seeking the perfect take. No fluffs. No stumbles. They want it to be just so. Eventually, they get it, but at what cost? That's not a good use of anyone's time. Nobody had told them that there is an easier way.

NOTE: I'll review some of the steps we have already learned earlier to give context.

Imagine you are going to make and present a video. It's an informative video about two minutes long. There have been three new software updates that your team needs to know about, and you want to get this video made, and sent, within the next half hour.

You open a document on your desktop and knock out a quick dot-point script, without *commas* and *acronyms*. You write any words that might give you trouble.

Intro
Dot Point 1
Dot Point 2
Dot Point 3
Call To Action

You do a quick *read* to identify the words that will give you problems. You zoom this document up to 200% screen view so it is nice and easy to read.

Zip It and Mark It

You run your fingers through your hair, check for spinach in your teeth, press record on your smartphone and zip it. *Zip* your lips, lock them and throw away the key. You say nothing, not a peep, not a whimper until you have two or three seconds of silence. You're off and running now. You whiz through your intro and get straight into point one. You end point-one and arghhh, you can't remember point two.

You *zip* it again, plus you hold your pose. Don't get up, don't shift your body weight from one bum cheek to the other, don't re-adjust your coat, just stay still, calm, relaxed and silent. Enjoy the quiet and after a few seconds, *clap it*. You will give three short claps. Not hard, not soft, just clap to the time of one, two, three without overthinking it.

Remain calm and posed and glance over at the zoomed up script and refresh yourself with point two. Maybe five seconds have passed, maybe ten or twenty. You are still right on target for a great video. Launch into your second point. It's going well until you completely lose your train of thought. Guess what you do? *Zip* it and hold your pose. Feel the lovely silence and when you are ready, present your second point. You're not

going to believe this but you bomb this section again ... yes ... *zip it*, hold your pose, relax and present it again and bingo! This one is a winner.

Nothing changes. *Zip it*, hold your pose and after a few seconds *clap it* ...and again, *zip it* and hold your pose and continue on until you have worked your way through your script. Finding this confusing? It'll be clear in a jiffy. There are only two things going on here.

1. Anytime you feel you have messed up and want to do that section again, keep following the *zip it* and hold your pose until you are happy. If this takes you ten attempts, that's ok.
2. When you have a take that you are happy with, you *mark it* as described with three claps.

Note that the camera keeps recording throughout this entire process. You do not pause it or stop it until the very end.

When you are satisfied you have the intro, all the points and the call to action covered—not perfectly but good enough—you stop recording. At this stage, you might have twelve minutes of recording for ninety seconds of the finished video. You're still right on target here.

Crush It

Now you will *crush it*. Have you ever crushed an aluminium drink can? You hold it horizontal between the heels of your hands, take a quick glance around to make sure no one sees you if you can't do it, then with one sudden inward snap of force, you crush the can to a tenth of its length. That's what we are going to do with your video. We are going to crush twelve minutes down to ninety seconds. It'll take a little longer than crushing a can, but it is surprisingly fast to do.

If you are fretting that I'm a bit light on with the operational and technical details, don't worry. It only takes a few buttons to show you which buttons to push.

You import the twelve minutes of raw video into your editing program, and after you've done a quick check of the pictures to see that you look half decent, then the only thing that will interest you is the audio timeline. Again, you'll learn the steps to do this. You'll surprise yourself with how easy it is. It will look like this.

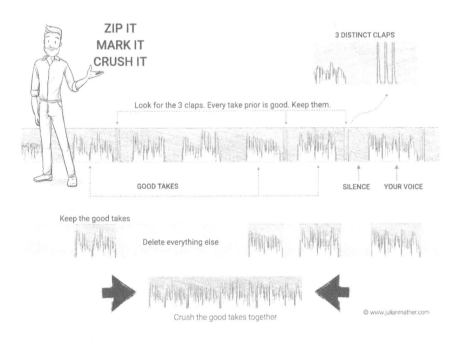

If you have never seen this before, the squiggly line is a graphic representation of your voice. The dark gaps are the silence in between your speaking. See how easy it is to see exactly where the speaking starts and where it finishes. That's why we use the discipline of silence.

But they aren't marked as point one, point two, etc. You did it with your claps. See the three straight lines? They are the three claps you made after every take you were satisfied with.

That means the squiggly lines immediately to the left of the three clap lines is the sound we want to keep, and everything else we will delete. They are all in the correct order because you followed your simple script.

Because we have used the discipline of silence, editing can be done to a high degree of accuracy by just looking at the edit timeline. You'll be surprised how fast this happens. Cutting and deleting is as simple as highlighting and deleting paragraphs from a text document. You'll master it very quickly. Like crushing the can to a fraction of its length, you have now completed your A roll.

If you edit soon after recording when everything is fresh in your mind, you might find that editing your own A roll like this, then outsourcing the rest works for you. To be clear, if you want to edit, go for it. It's a great skill to have. I have online courses to help you. A CVO: Chief Video Officer - as I suggested in the previous chapter - would be the perfect person for you to hand over your editing to at this stage.

Edit-Less Editing

One of the ideas I promote is that you can't win the new video game playing by the old rules. To put that in context, there have been two big changes to the way I make videos and both changes have happened in the last five years of a forty-year video career.

The first was the move from conventional video cameras to smartphones. The second and by far the most game-changing, has been using live streaming software to record the videos I make for my business. Just as you can watch a sporting event LIVE, or you can watch the recorded replay afterwards, we can use a whole new range of tools to make professional-looking live streams onto social platforms or we can record them for later use.

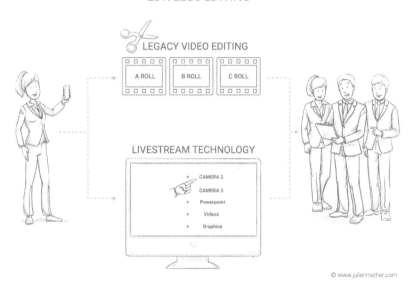

Just as a TV sporting event cuts from one camera to another camera angle to a video replay, to a scoreboard, to the commentators and back again, this same technology allows us to make videos where we can cut from our camera to our PowerPoint presentation to videos to drawing diagrams on an iPad. It's like we can go between A roll and B roll and C roll in any order we like, at the touch of a button. We still have to plan beforehand. We script. We make our graphics. We get videos ready. We get everything in order. So why bother?

Livestream Software Is the Future

This is what excites me about this process.

- If the final video is ten minutes long, it takes ten minutes to make.

- You can pause and restart the recording as often as you like. So if you are losing your way, you can pause, gather your thoughts, restart. The edits are perfect. It's all done with the push of a button.

- You can bring multiple guests in and out of your recordings at any time.

- You can play, pause, replay videos.

- You can add professional dissolves | effects as you go.

- You can have calls to action, URLs, phone numbers pop up on the screen anytime you want.

- The pressure on you to be perfect is gone. Viewers expect LIVE programs to have mistakes. You can have some fun while making them.

- We can use our home computers and the software is inexpensive.

To be clear, you can actually go LIVE onto platforms like Facebook and LinkedIn and record at the same time, or you can just record to your hard drive. You might be wondering, can't I just do this using Zoom for free? The difference is the quality. Instead of blurred video with freezes

and lags, this way you can record in 1080 and even 4K. Remember that's cinema quality.

Are you excited about the possibilities? At times, I'm close to being slack-jawed at how easy it is becoming to make a video that was not long ago, the domain of film and TV industry professionals.

Watch me make an
edit-less editing
video

This is too big of a topic for this book. I can mentor you through the process. You can take one of my online courses. Right now, what's important for you and your business is to understand that this software is going to play a high part in the future for new video professionals who want to consistently turn up on video to help their clients. I make four out of every five videos this way now. You need to factor it into your plans.

Record Once, Deliver Often

Now that we can make longer videos with ease, you will. You need longer content. Even though I have written about short videos, the real game is mixed media: short, long, video, written, audio, visual. If you make longer content it is getting easier to repurpose that content into shorter content. I mentioned this earlier in this book. What I didn't say was AI and machine learning and growing computing power at cheaper prices is making this a growth industry. Every year it gets easier and faster. Now you can upload your video podcast, it is automatically tran-

scribed. You can scan the transcription, highlight short sections of text and the software will make you as many complete, branded, captioned videos as you want, and in the multiple aspect ratios for different platforms. The software is simple enough that you can train up an assistant to do this for you.

I've Said What I Need to Say

There are two things that really interest me: video and change. In actively pursuing change in my own life, I've learned that change is not a process; it's a decision. If you decide not to change, no one can make you. If you decide to change, no one can stop you.

Have my arguments moved you towards action? Do you believe that the world is hungry for truth, that a desire to help clients makes you the right person to show up on video for them, that the pressure on you to be perfect is gone, that this whole video thing is just getting easier?

You have heard enough to make a decision. Do you want to be a new video professional? Because you need to decide now whether or not you want in. There's a window of opportunity to get ahead of the horde. Sending a video will be as commonplace as sending an email. If you want to take the next step, the next chapter is the place for you.

" Before I met Julian I had never made a video. In the three weeks after I met him, I not only posted videos every few days, I did my own video editing "

Serene Seng, Director of Corporate Engagement, Singapore

" Julian gave our staff not just the tools and templates to create great DIY videos and messages, but the confidence and go-ahead to put theory into practice "

Tim Moore, Department of Environment and Science, Queensland

" Absolutely brilliant whether live or virtual "

Dr Neryl East, Communications Expert

" Julian's storytelling and entertaining delivery are 'can't look away' compelling "

Sarah Oxlade, Transformation Specialist, Telstra

" There are speakers who offer you fresh perspectives as subject matter experts. Those who speak with the rousing fervour of evangelists. Those who are so just so enjoyable to listen to as storytellers. Julian was all three in one compelling package "

Coen Tan, Ministry of Influence, Singapore

Next Steps

Take Action

Grab your phone. Press the red button. Don't think, just tell a client why you appreciate them. Make a half dozen of these. When the replies come in you'll understand the power of authentic video for your business.

Join the New Video Professional Club. You'll be in the good company of people like you, solving problems like yours.

Want video coaching? Book a 15-minute laser session to discuss.

Book me to speak at your event.

Recommend me as a guest for podcasts.

Give me a recommendation on Linkedin.

Buy bulk books for your team.

Review this book.

Join the New Video
Professionals Club

Ready for
coaching? Book a
15 min laser
session to discuss

Book Julian to
speak

Give Julian some
Linkedin Love

email Julian

References

Chapter 1

1. Name and publication date available upon request.
2. https://www.thinkwithgoogle.com/marketing-strategies/video/online-video-shopping/
3. https://storage.googleapis.com/think/docs/think-with-google-2019-research-review.pdf
4. https://juliemasters.com/ The Influencer Code

 https://hbr.org/2016/07/a-global-survey-on-the-ambiguous-state-of-employee-trust

 https://news.gallup.com/opinion/gallup/211793/ceos-employees-trust.aspx
5. https://juliemasters.com/the-unskippable-future/
6. https://seekingalpha.com/article/3992427-facebook-fb-mark-elliot-zuckerberg-on-q2-2016-results-earnings-call-transcript?part=single
7. https://www.merriam-webster.com/dictionary/amateur#:~:text=The%20earli-est%20sense%20of%20amateur,%E2%80%9Clover%E2%80%9D%20(amator)
8. https://www.jordanharbinger.com/sammy-the-bull-gravano-mafia-underboss-part-one/

Chapter 4

1. Gary Vaynerchuk has said this numerous times on podcasts.
2. From Speakership by Matt Church, Sacha Coburn & Col Fink p.37

Chapter 6

1. https://newsroom.tiktok.com/en-us/longer-video
2. Pinvidic, Brant. The 3-Minute Rule (p. 3). Penguin Publishing Group. Kindle Edition.
3. Unskippable Labs. The Mobile ReCut https://www.youtube.com/watch?v=6HHgzEGwil4
4. However, the number of videos in the 30–60 minute category in 2020 grew 140% year-over-year and 446% since 2016, highlighting the increased investment in long-form content as more companies embrace video series. Impactful and story-dri-

ven long-form videos have seen tremendous growth as brands sought to build a connection and loyal audience. In general, engagement is highest for the first few minutes of video (typically above 50% for the first three minutes) and drops steadily after that mark. So, viewers that continue to watch are more engaged and are strong candidates for additional content from the brand. https://wistia.com/learn/marketing/announcing-the-2021-state-of-video-report

Chapter 7

1. https://techcrunch.com/2018/10/22/the-future-of-photography-is-code/

Chapter 8

1. https://www.facebook.com/groups/newvideoprofessionalsclub
2. https://www.scientificamerican.com/article/video-looks-most-natural-horizontally-but-we-hold-our-phones-vertically/

Chapter 9

1. Credit to author Polly LaBarre for the term jargon monoxide
2. Attributed to George Carlin
3. https://juliemasters.com/julie-masters-lessons-learned-from-100-episodes/

Chapter 10

1. https://www.jordanharbinger.com/

Chapter 12

1. https://www.statista.com/statistics/276748/average-daily-tv-viewing-time-per-person-in-selected-countries/
https://www.statista.com/statistics/730428/tv-time-spent-worldwide/
https://en.wikipedia.org/wiki/Television_consumption

Printed in Australia
AUHW011610280122
358856AU00019B/60

9 780648 524038